Masterpieces
of the J. Paul Getty Museum

DECORATIVE ARTS

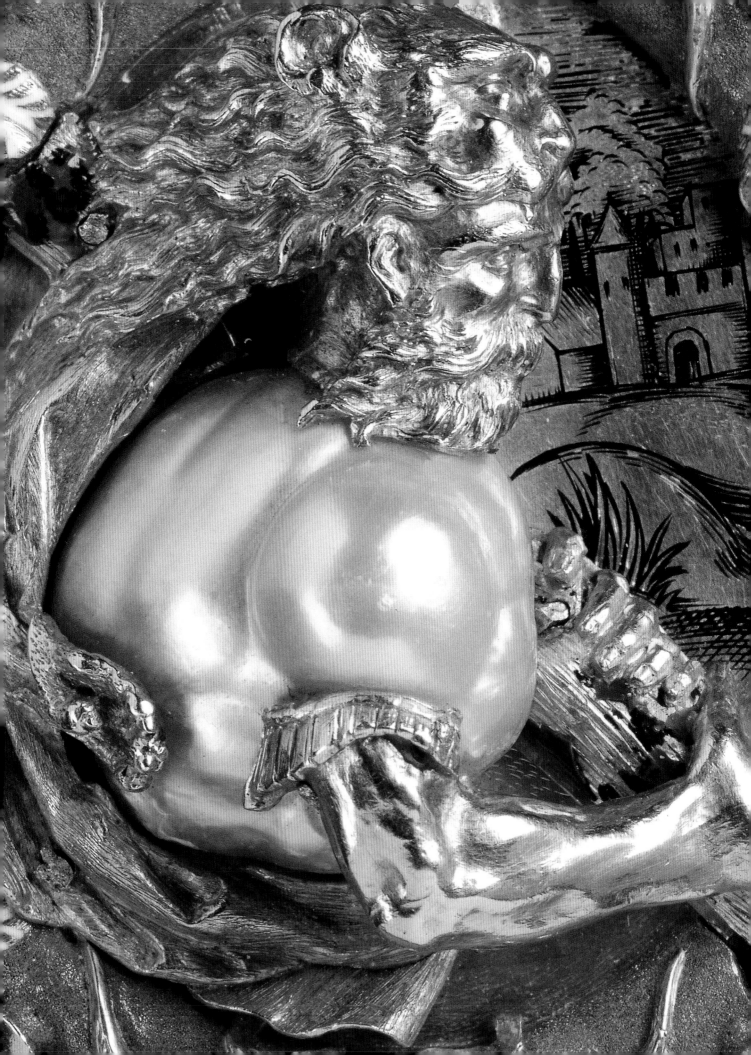

Masterpieces
of the J. Paul Getty Museum

DECORATIVE ARTS

Los Angeles
THE J. PAUL GETTY MUSEUM

Frontispiece:
Hercules Pendant [detail]
French (Paris), circa 1540
85.SE.237 (See no. 9)

At the J. Paul Getty Museum:

Christopher Hudson, *Publisher*
Mark Greenberg, *Managing Editor*
John Harris, *Editor*
Amy Armstrong, *Production Coordinator*
Jack Ross, *Photographer*

Text prepared by Charissa Bremer-David, Catherine Hess,
Jeffrey W. Weaver, and Gillian Wilson

Designed and produced by Thames and Hudson
and copublished with the J. Paul Getty Museum

Library of Congress Card Number 96-26469

ISBN 0-89236-455-6

Color reproductions by CLG Fotolito, Verona, Italy

Printed and bound in Singapore by C.S. Graphics

CONTENTS

DIRECTOR'S FOREWORD

In 1936 J. Paul Getty rented a sumptuously furnished apartment in New York belonging to Amy Phipps Guest. Never having shown any particular interest in furniture and the decorative arts before this time, Getty thereafter became a serious collector. "To my way of thinking" he wrote later, "a carpet or a piece of furniture can be as beautiful, possess as much artistic merit, and reflect as much creative genius as a painting or a statue." It was to his advantage that the entire art market was depressed in the 1930s, when he got started. Getty believed that great works of decorative art were undervalued in relation to paintings, and this gave him a further incentive to specialize. And specialize he did: he bought eighteenth-century French pieces almost exclusively.

In 1971 Getty hired Gillian Wilson as curator, inaugurating a twenty-five-year period of remarkable purchases that broadened and greatly strengthened the Getty Museum's collection. Boulle furniture and many other objects of the late seventeenth century pushed the chronology back; a fishbowl chandelier of the early nineteenth century pushed it forward. Mounted Chinese and Japanese porcelain, Sèvres porcelain, tapestries, and clocks were bought in enough numbers to form impressive subcategories. Handsomely installed on the upper floor of the re-created Roman villa that Getty had built to house the Museum, French decorative arts for many years have formed the Museum's most mature and consistently excellent collection.

When Getty died in 1976, he made a bequest to the Museum worth more than seven hundred million dollars. This made many new things possible. The Museum would be able to build much more important collections; the Getty Trust could create organizations parallel to the Museum to do innovative work in scholarship, conservation, and art education; and a larger museum could be built as part of a Getty campus.

One of the first decisions made in the early 1980s, when the income from Getty's bequest was about to flow, was to expand the collection to include European sculpture and also to buy European furniture and decorative arts outside the Museum's traditional French boundaries. In 1984 Peter Fusco joined the staff as curator of a new Department of Sculpture and Works of Art. Since then, major groups of material have been bought and shown in their own galleries, such as glass and maiolica; furniture from Italy and the Low Countries has gone into the paintings galleries; and silver- and goldsmiths' work, together with all manner of precious objects made for cultivated tastes from the Renaissance through the nineteenth century, has been put on display as well. Many of these objects have been published over the years in the Museum's specialized collection catalogues and in the summary catalogue of the decorative arts collections; the Museum's collection of sculpture—itself a distinguished creation of the

past dozen years—is not included in the present volume but will have its own book of masterpieces, as well as a summary catalogue and a detailed, two-volume collection catalogue.

In the new museum designed by Richard Meier at the Getty Center in west Los Angeles, galleries are being readied as I write. French decorative arts and furniture will be shown in a suite of fourteen rooms designed by Thierry Despont in the styles of various periods. On either side of this French enclave will be nine galleries especially designed for the decorative arts and sculpture of other European countries, and there will be some objects in the paintings galleries as well. We have tried to provide settings for these marvelous things to make them look their best and to give them a suggestive context. We hope that this book—so carefully prepared by Charissa Bremer-David, Catherine Hess, Jeffrey W. Weaver, and Gillian Wilson of the Decorative Arts and Sculpture departments—will inspire readers to come see for themselves.

JOHN WALSH
Director

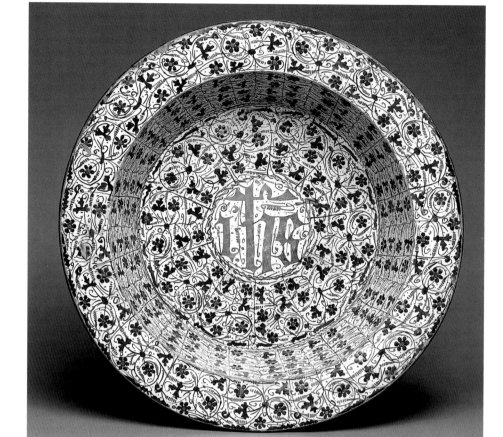

1 Hispano-Moresque Deep Dish
 (*Brasero*)
 Spanish (Valencia),
 mid-fifteenth century

Tin-glazed earthenware embellished
with luster
Height: 10.8 cm (4¼ in.)
Diameter: 49.5 cm (19½ in.)
85.DE.441

Renaissance ceramics decorated with luster were prized not only for the shimmering iridescence of their ornament but also for their seeming transformation of base materials into gold—the dream of alchemists since the Middle Ages.

Lustered ceramics, first produced around 800 A.D. in what is now Iraq, reached the Spanish town of Málaga—the westernmost point of the Islamic world—in the thirteenth century. From there, knowledge of the difficult technique moved up the coast to the region of Valencia. By the fifteenth century, Valencian lusterware was being sent to Italy, particularly Florence, where it was bought by wealthy clients. That many of these ceramics traveled by way of Majorca explains the derivation of the name that fifteenth-century Italians used for Spanish lusterware: maiolica. Not until the sixteenth century did it come to be used for all types of tin-glazed earthenware.

The center of this dish is inscribed with the sacred monogram *IHS* (for "Iesus Hominum Salvator," Jesus the Savior of Men). It may have been used as a serving trencher at table or—given its large size, elaborate decoration, and excellent state of preservation—have been intended primarily for display, perhaps on a sideboard.

2 "Oak-Leaf" Jar
(*Orciuolo Biansato*)
Italian (Florence),
circa 1425–1450

Tin-glazed earthenware
Height: 39.4 cm (15½ in.)
Max. width: 40 cm (15¾ in.)
Diameter (at lip): 19.4 cm (7⅞ in.)
84.DE.97

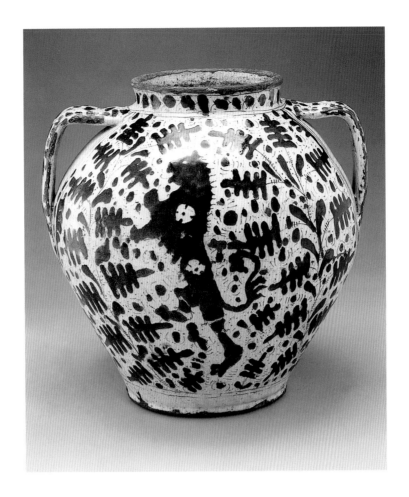

This jar is the largest known example of its kind. Its overall leaf decoration and rampant lions are painted with a thin variant of the more common *zaffera a rilievo* (relief blue) impasto, a dense pigment preparation that was painted on thickly, causing it to stand out from the surface of the pot after glaze firing. The rampant lion on either side is particularly appropriate as a Florentine motif, since it may refer to the city's lion emblem, or *marzocco*. It could also derive from Italian heraldic images or from patterns found on other decorative arts, such as textiles.

A painted asterisk under each handle probably refers to the workshop in which the jar was made, in this case that of Giunta di Tugio (circa 1382–circa 1450), the most important potter of his time in Florence. Di Tugio's reputation is due, at least in part, to the large commission he received around 1430 from the Florentine hospital of Santa Maria Nuova for nearly one thousand pharmaceutical jars, several of which survive.

3 Ewer
 Italian (Murano), late fifteenth
 or early sixteenth century

Free-blown soda glass with gilding
and enamel decoration
Height: 27.2 cm (10^{11}/$_{16}$ in.)
Max. width: 19.3 cm (7^5/$_8$ in.)
Diameter (at lip): 2.9 cm (1^1/$_8$ in.)
Diameter (at base): 13.9 cm (5^7/$_{16}$ in.)
84.DK.512

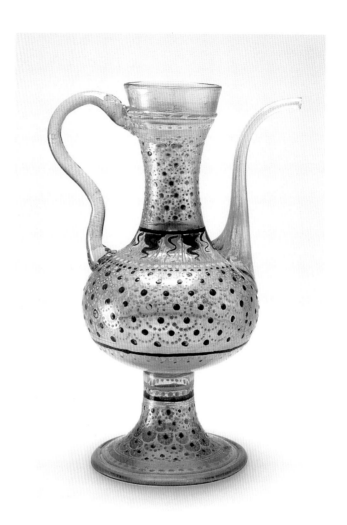

This ewer is a superb example of a Renaissance luxury vessel. Translated from an earlier metalwork shape that was frequently used for liturgical vessels, glass ewers of the fifteenth century often held wine or other liquids at the dining table. This example is assembled from four different parts that were first gilt and enameled before they were joined.

The wavelike pattern around the neck recalls the insignia—composed of sun rays surrounding the holy monogram *IHS*—belonging to followers of Saint Bernard of Siena. However, this motif might have been used here solely for decorative effect. The form of the piece and details of the enameling bring to mind Islamic prototypes, while the "fish-scale" gilding punctuated by dots is characteristic of Venetian glass of the period.

Interestingly, the closest known counterpart to this vessel—a deep blue ewer—is also found in Southern California, at the Los Angeles County Museum of Art.

4 Display Plate (*Piatto da Pompa*)
 Italian (Deruta),
 circa 1500–1530

Tin-glazed earthenware embellished
with luster
Height: 8.8 cm (3½ in.)
Diameter: 42.9 cm (16⅞ in.)
84.DE.110

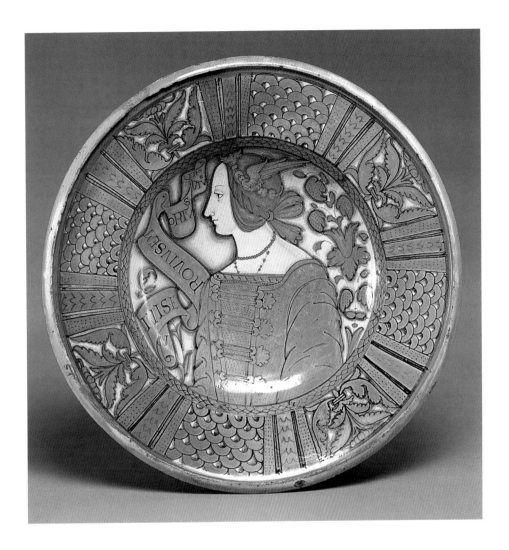

Idealized female images like the one on this plate were clearly influenced stylistically
and iconographically by the work of such painters as Perugino (circa 1450–1523) and
Pinturicchio (circa 1454–1513), both of whom were born in Umbria, the region in
which Deruta is located. (Indeed, Pinturicchio's wife was the daughter of a potter from
Deruta.) Similar classicizing busts in profile—of men as well as women—often appear
on Deruta maiolica and are often nearly identical in pose and appearance. Presumably
the ceramic images were copied from drawings or prints that, in turn, likely recorded
important works of art in the vicinity of the workshop.

 The inscription on the scroll reads *VIVIS ERO VIV[U]S E MORTV[U]S ERO
VIV[U]S* and might be interpreted as "When alive, I shall be among the living,
and when dead, I shall [still] be among the living." This statement may signify the
undying love of the plate's patron for the woman, depicted in profile, who had died.

 Derutan potters closely imitated Hispano-Moresque products for their own
lusterware, using silver oxides to produce a yellowish, brassy appearance. Potters from
neighboring Gubbio, the other major Italian center capable of producing lustered
maiolica, used copper oxides to create a more luminous, ruby-red iridescence.

5 Bowl of a Footed Beaker
 Probably Bohemian or possibly
 Italian (Murano),
 circa 1525–1575

Free-blown soda glass with gilding,
enamel, and diamond-point engraved
decoration
Height: 22 cm (8⅝ in.)
Diameter (at lip): 19 cm (7½ in.)
Diameter (at base): 7.8 cm (3¹⁄₁₆ in.)
84.DK.547

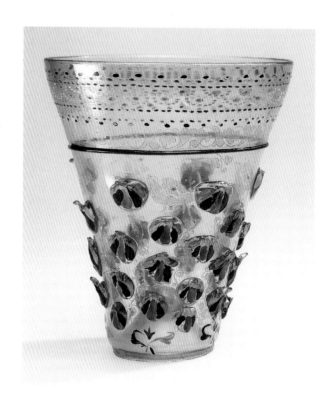

This important piece displays an unusual combination of Venetian and
Northern elements. While the trailed cobalt band, colored bosses or prunts,
and gilt-and-enamel "fish-scale" pattern around the lip are characteristic of
glass from Murano, the pointed prunts and conical body give the piece a
distinctly Northern appearance.

 The top-heavy proportions of this vessel and the abraded appearance
of the bottom edge suggest that the original foot broke off; someone then
tried to minimize the break by grinding it down, thus salvaging the bowl
of the original vessel.

6 Covered Beaker (*Willkommglas*)
 Austrian (Hall in Tirol),
 circa 1550–1554
 Possibly the workshop of
 Sebastian Höchstetter
 (1540–1569)

 Free-blown potash glass with enamel
 and engraved decoration
 Height (with lid): 37 cm (14 %₁₆ in.)
 Height (without lid): 28.5 cm
 (11¼ in.)
 Diameter (at lip): 12.4 cm (4⅞ in)
 Diameter (at base): 14.3 cm (5⅝ in.)
 84.DK.515.1–.2

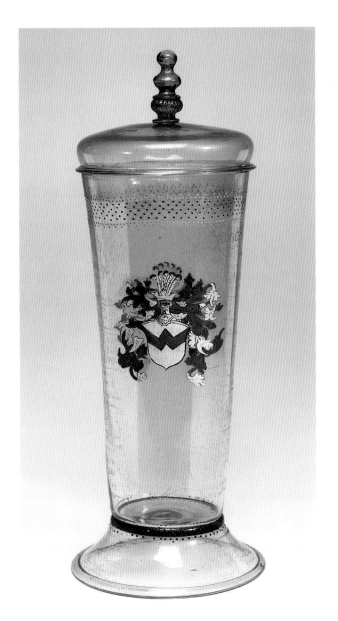

This is the earliest engraved *Willkommglas* to have survived. It must date before 1555,
because the enameled coat of arms on both sides of the beaker, identifying its owners as
forebears of the Trapp family, were redesigned in that year to incorporate the inherited
arms of another family.

This "welcome" glass was used in toasting and receiving guests, many of whose
inscribed names and personal devices cover this otherwise simple object. Indeed, this
vessel served as a kind of guest register, recording the names of distinguished visitors
and the dates of their visits. All but one of the inscriptions date from 1559 to 1629
and include such notable individuals as Archduke Ferdinand of Tirol and his nephew
Maximilian I, as well as members of important families from the Tirol and elsewhere,
including the von Pranckh, von Fuchstatt, von Westernach, von Scherffenwerg, and
von Oppersdorff families.

While the ornamental band below the lip—with enamel and gilded dots—derives
from Venetian glass decoration, the form of the piece and the brownish-gray cast to
the glass itself are characteristic of Tirolean production.

7 Pilgrim Flask
 French
 (Puisaye region of Burgundy),
 early sixteenth century

 Cobalt-glazed stoneware
 Height: 33.5 cm (13³⁄₁₆ in.)
 Width: 23.5 cm (9¼ in.)
 Depth: 13 cm (5⅛ in.)
 95.DE.1

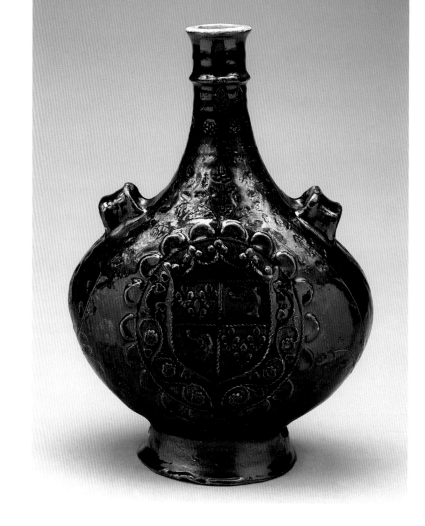

This flask is one of the most important surviving pieces of *grès bleu de Puisaye,* the earliest stoneware produced in France for aristocratic patrons. A number of Puisaye stoneware objects display royal heraldry, including the arms of such important French families as the Bochetels, Rolins, Ferrières, and de la Chaussées. The production of *grès bleu de Puisaye*—so called because of its brilliant cobalt-oxide glaze, probably imported from the Middle East—has been traced to the last quarter of the fifteenth century, when François de Rochechouart, chamberlain of the duc d'Orléans and of the future Louis XII, married Blanche d'Aumont and established a stoneware factory in Saint-Amand. D'Aumont, a native of the Beauvais region where stoneware was being produced from at least the mid-fifteenth century, might have helped bring the technology of stoneware production to the Puisaye.

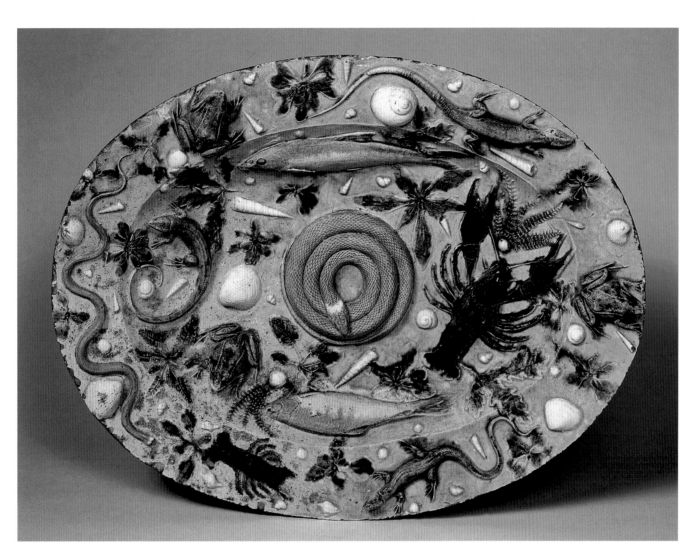

8 Oval Basin
French (Paris), circa 1550
Attributed to Bernard Palissy
(Saintes, 1510?–1590)

Lead-glazed earthenware
Length: 48.2 cm (19 in.)
Width: 36.8 cm (14½ in.)
88.DE.63

A man of many interests and talents, Bernard Palissy was a scientist, religious reformer, garden designer, glassblower, land surveyor, philosopher, and geologist, as well as a ceramist. He is best known for his so-called *figulines rustiques,* or rustic ware, which he made by creating life casts of crustaceans, plants, and reptiles, and attaching the casts to traditional ceramic forms. Palissy then naturalistically decorated these objects with runny lead-based glazes, increasing the realism of the aquatic environments.

His rustic ware met with great success, and Palissy was commissioned by both Anne de Montmorency and Catherine de' Medici around midcentury to execute the decoration of the grottoes in their private gardens, evocative settings that were used in the sixteenth century for diversion and contemplation. Palissy's ceramics were so popular that they were imitated during his own lifetime and copied in the nineteenth century by such notable ceramic factories as Sèvres in France and Wedgwood in England, as well as by numerous French imitators and counterfeiters.

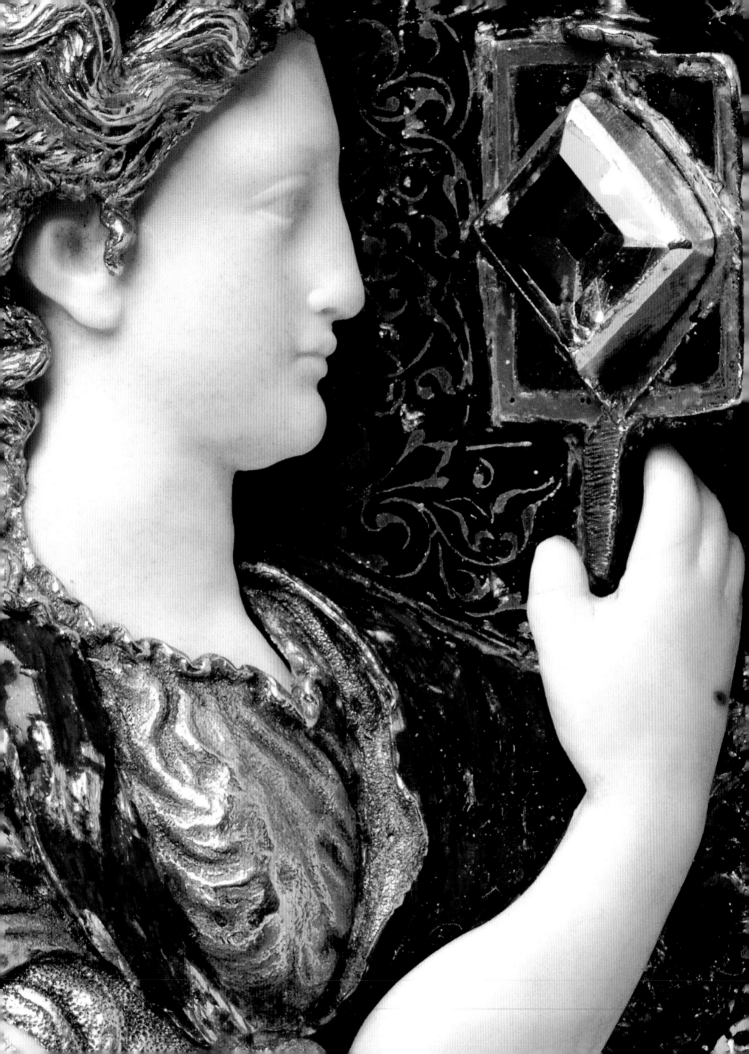

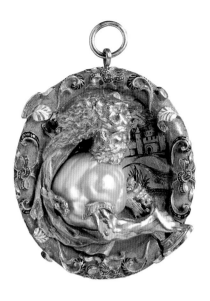

9 Hercules Pendant
 French (Paris), circa 1540

Gold; white, blue, and black enamel;
and a baroque pearl
Height: 6 cm (2⅜ in.)
Width: 5.4 cm (2⅛ in.)
85.SE.237

Presumably made to be worn by a man, since qualities of its subject were meant to reflect on its wearer, this pendant depicts Hercules erecting the pillars at Cadiz, one of his Twelve Labors. The subject is depicted in high relief on the obverse and in *champlevé* enamel on the reverse (that is, with the enamels poured into grooves engraved on the metal surface and then polished). According to different accounts, Hercules either raised the two mountains as monuments to his progress or split one mountain in two, forming the Straits of Gibraltar to discourage the entry of sea monsters into the Mediterranean.

Rarely portrayed, this subject was chosen by François I to celebrate the visit of Charles V, his brother-in-law, to Paris in 1540. Indeed, the style of this pendant is especially close to that of artists working for François at Fontainebleau, particularly Benvenuto Cellini, the most prominent goldsmith there. Its unusual subject, sumptuous materials, and exquisite workmanship indicate that this pendant was probably a royal commission.

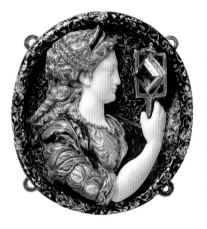

10 Prudence Hat Badge
 French (Paris), 1550–1560

Gold; white, blue, red, and black
enamel; chalcedony; and a table-cut
diamond
Height: 5.7 cm (2¼ in.)
Width: 5.2 cm (2¹/₁₆ in.)
85.SE.238

Detail at left

This type of jewel was worn as a dress accessory on the turned-back brim of a hat or cap, fastened by a pin or by stitches through metal hoops attached to the back. It remained in vogue from about the middle of the fifteenth century to the second half of the sixteenth. *Commessi* such as this badge are a rare jewel type, created through the close collaboration of French and Italian artists. (Such collaborations were more frequent after the Sack of Rome in 1527, when many Italian artists were driven to France in search of work.) The term *commesso* refers to the process by which stones were "committed," or attached together in a jigsaw-puzzle manner; the technique was often used to restore ancient gems.

The subject of this work is the allegorical figure of Prudence, who—with Justice, Fortitude, and Temperance—was one of the four Cardinal Virtues. Signifying wise conduct, she is depicted holding a mirror that she uses to see herself truthfully and insightfully. Because of its subject, this jewel was likely intended to be worn by a woman, possibly to invite Prudence's protection or acquire the virtues she personifies.

11 Pair of Firedogs
 French (Fontainebleau, by
 an Italian artist), 1540–1545

 Bronze
 Height: 85.1 cm (33½ in.)
 Width (at base): 40.6 cm (16 in.)
 94.SB.77.1–.2

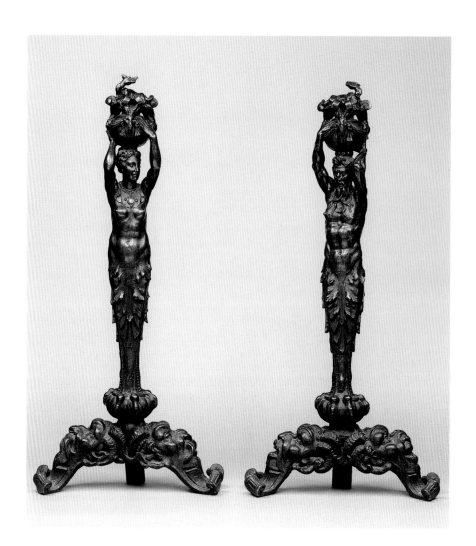

These figures in a caryatid form—here supporting urns rather than an entablature
—served as firedogs, the fireplace equipment that supports wood in a hearth. The
fantastic composite figures of nymph and satyr, the decorative use of strapwork, and
the presence of a salamander (a personal emblem of François I) atop the urn of each
piece, all strongly suggest that the sculptures were designed for placement in the king's
château at Fontainebleau. The elegant and expressive Mannerist style of the works
indicates they were done by an Italian artist active in the Fontainebleau workshop.
Indeed, the satyr's twisted pose, vigorously modeled musculature, and emotional
expressiveness, along with the nymph's elongated proportions and chilly classicism,
have much in common with the work of both Rosso Fiorentino (1494–1540)
and Francesco Primaticcio (1504–1570), who worked on the king's château in the
first phase of its decoration around 1540. These are, arguably, the earliest known
figural firedogs.

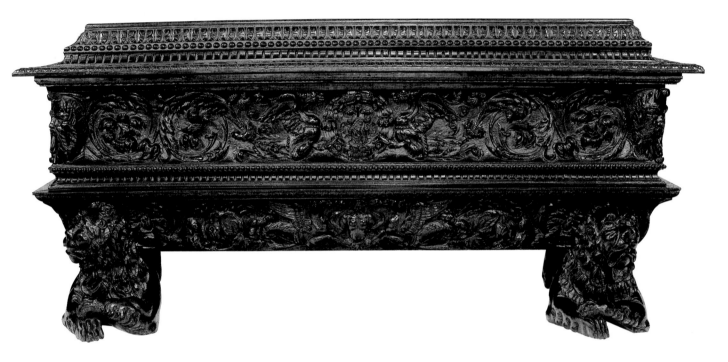

12 One of a Pair of *Cassoni*
 Italian (Umbria), dated 155(9?)
 Attributed to Antonio Maffei
 (Gubbio, born circa 1530)

Carved walnut, originally parcel gilt
Height: 75 cm (29½ in.)
Width: 181.5 cm (71½ in.)
Depth (at top): 59 cm (23¼ in.)
Depth (at feet): 76.2 cm (30 in.)
88.DA.7.1

Most Renaissance *cassoni* were given to newly betrothed couples to celebrate their marriages and help furnish their new homes. Both the prominently displayed coat of arms as well as a handwritten label found inside this chest suggest that the pair of *cassoni* were executed for the marriage of Pressilla de' Conti of Foligno to her second husband, Cesare Bentivoglio of Gubbio, in the mid-sixteenth century.

The artist was most likely Antonio Maffei, the most lauded member of a famous Umbrian family of sculptors and decorative carvers in wood. Both chests display the deeply carved scrolling foliage, pronounced architectural motifs, and sarcophagus-like monumental shapes typical of the High Renaissance. Their bizarre grimacing masks and grotesque figures reveal an early Mannerist interest in strange and elegantly contorted forms.

This chest and its companion are very rare examples of intact furniture datable with certainty to the mid-sixteenth century. Their date is secured not only by the informative label under this object's lid, probably dating to the eighteenth century if not earlier, but also by the fact that both chests were carved for the most part from a single tree trunk and so could not have been much altered at later dates.

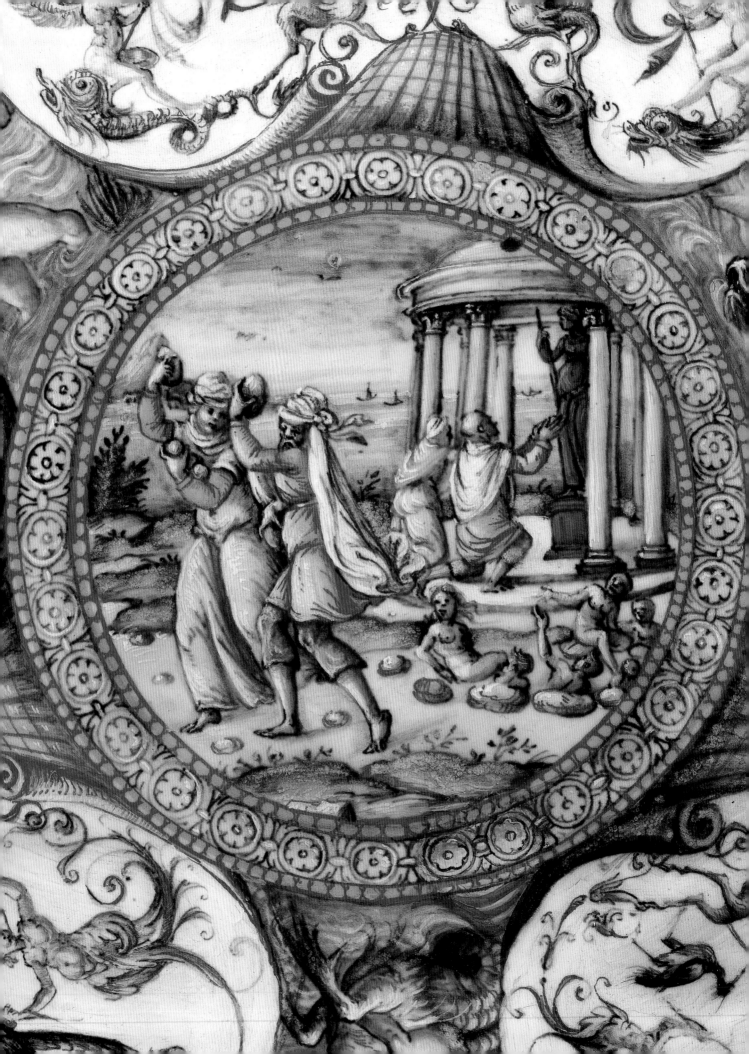

13 Basin with Deucalion and Pyrrha
 (*Bacile Trilobato*)
 Italian (Urbino),
 circa 1565–1575
 By Orazio Fontana
 (Castel Durante, 1510–1571)
 or his workshop

 Tin-glazed earthenware
 Height: 6.3 cm (2½ in.)
 Diameter: 46.3 cm (18¼ in.)
 86.DE.539

 Detail at left

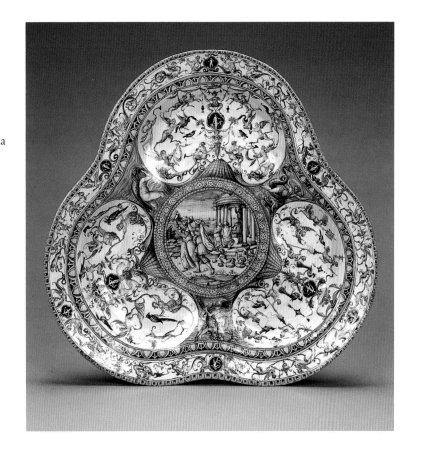

Basins of this type were most likely used to offer scented water to guests at the dining table so that they could wash their hands between courses. The elaborate form and decoration of this piece, however, suggest that it was used solely for display. The central scene (see detail at left) tells the story of Deucalion and Pyrrha from Ovid's *Metamorphoses* (book 1, lines 315–415). According to the legend, this husband and wife survived a deluge sent by Zeus and found their way to a temple on Mount Parnassus to ask the gods how they might renew the human race. When informed that they must throw behind them the bones of their mother, Deucalion understood that the oracle meant their mother the earth. The pair began casting down stones that, upon hitting the earth, assumed human form.

Orazio Fontana was one of the most sought-after and innovative ceramists of the mid-sixteenth century. He helped develop a new genre of maiolica decoration inspired by Raphael's frescoes in the Vatican Loggie, which in turn were inspired by antique paintings that had recently been rediscovered in the "grotto" known as the Domus Aurea, Nero's "Golden House," in ancient Rome. Known as Raphaelesque or grotesque motifs, these elegant and fantastic embellishments began to cover increasingly large areas of Orazio's works; in later and more "Baroque" shapes, such as this basin, grotesques dominate the decoration, while the more traditional Renaissance narrative scenes are relegated to medallions or cartouches.

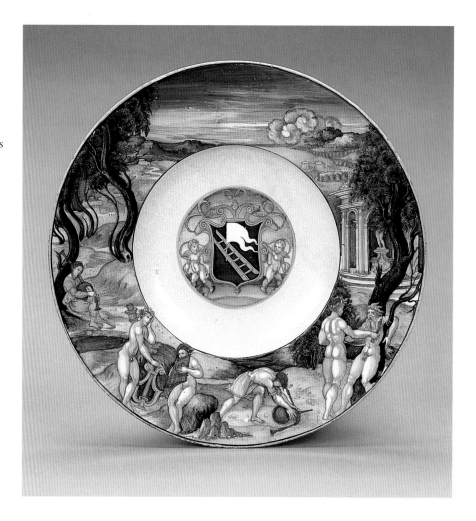

14 Plate with the Flaying of Marsyas
 Italian (Urbino), mid-1520s
 By Nicola di Gabriele Sbraghe,
 known as Nicola da Urbino
 (Urbino, circa 1480–1537/38)

 Tin-glazed earthenware
 Height: 5.7 cm (2¼ in.)
 Diameter: 41.4 cm (16⁵⁄₁₆ in.)
 84.DE.117

The painter of this plate was arguably the most talented and celebrated maiolica
artist of the sixteenth century, who signed his works *Nicola da Urbino*. His pieces
are characterized by a delicate and sophisticated rendering of figures and space in an
exceptionally rich and varied palette. Because of his great skill, Nicola's work was much
sought after by important sixteenth-century patrons of maiolica. Around 1525, for
example, he produced a splendid table service for Isabella d'Este, and another, in the
1530s, for Duke Federico, Isabella's son. The Getty plate belongs to yet another service
that was commissioned by or given to a member of the Calini family from Brescia,
whose coat of arms appears in the central shield.

 The scenes on this plate are adapted from two sheets in the 1497 Venetian edition
of Ovid's *Metamorphoses,* one telling the mythological story of Apollo and Marsyas and
the other depicting the contest between Apollo and Pan. The conflation of these two
prints explains why Marsyas is portrayed as both a young and an old man.

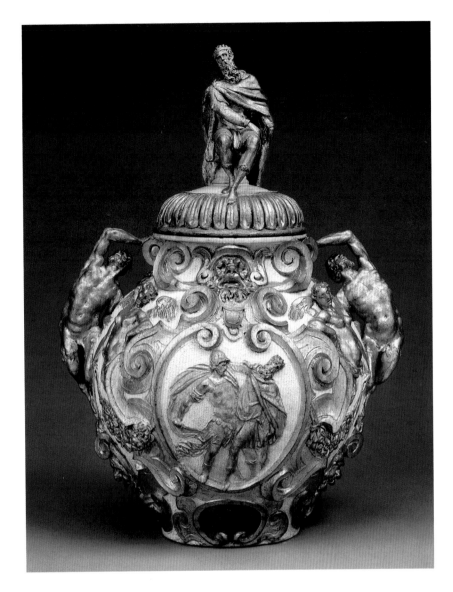

15 One of a Pair of Drug Jars
 Northern Italian,
 circa 1580–1590
 Attributed to Annibale Fontana
 (Milan, 1540–1587)

Painted and gilt terracotta
Height: 52 cm (20½ in.)
Diameter (at lip): 17.8 cm (7 in.)
Max. diameter: 40 cm (15¾ in.)
90.SC.42.1

This elaborately modeled drug jar was made to contain a specific medicinal preparation: *antidotum mithridaticum,* named for King Mithridates VI, who invented it and whose life provides the basis for much of the jar's decoration. Mithridates ascended to the throne of Pontos in 111 B.C. An amateur pharmacist fearful of being poisoned by his enemies, Mithridates concocted his own antidote, which he ingested on a regular basis. After a failed military campaign against the Roman Empire, he attempted to commit suicide by taking poison, but, because of his daily diet of the prophylactic, he was unsuccessful. In desperation, Mithridates was forced to have himself slain by one of his own guards. This pharmaceutical became very popular, especially in northern Italy and France, where it was produced for centuries, necessitating a steady stream of vessels in which to store it.

The elaborate strapwork, masks, and the relief and figural ornamentation provide a rich sampling of late-sixteenth-century Italian embellishment. The figures' dancelike poses, the animated relief scenes, and the vigorously modeled yet elegant nudes of slightly attenuated proportions—at once sensuous and bizarre—are typical of Mannerism and are closely related to the work of the most important Milanese sculptor of the period, Annibale Fontana.

16 *A Candelieri* Plate
Italian (Venice),
circa 1540–1560

Tin-glazed earthenware
Height: 5.7 cm (2¼ in.)
Diameter: 47.7 cm (18¾ in.)
84.DE.120

Detail at right

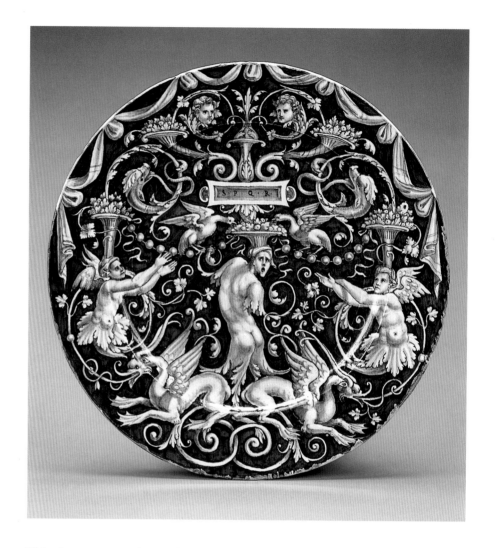

This plate appears to be a unique masterpiece: no other maiolica object of the period approaches its elegance and sophisticated rendering of figures and decoration. The central figure (see detail at right) is both graceful and bizarre, a favorite effect of Mannerist artists; the expression of surprise, the elongated proportions, and the twisted torso that ends in foliage and leafy scrolls all contribute to its fantastic nature. Also favored by the Mannerists was an extreme elegance in surface decoration, exemplified on this plate by such details as the beautifully draped fabric along the upper edge and the way in which the grotesque figure on the right gracefully crosses his left hand over his right arm, throwing a shadow on his extended forearm.

The decoration is displayed *a candelieri,* that is, symmetrically relative to a central axis, as if it were a candelabrum. Although this type of painting is most often associated with maiolica from Castel Durante, this plate's large and shallow form and its grayish-blue ground are typical of Venetian wares.

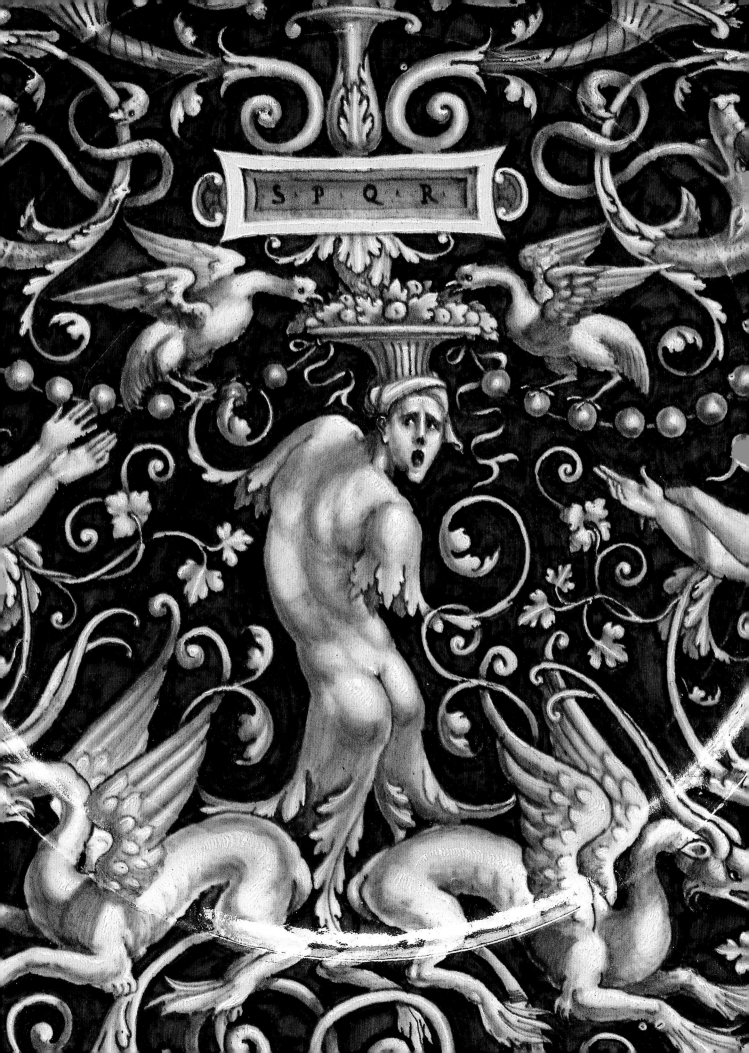

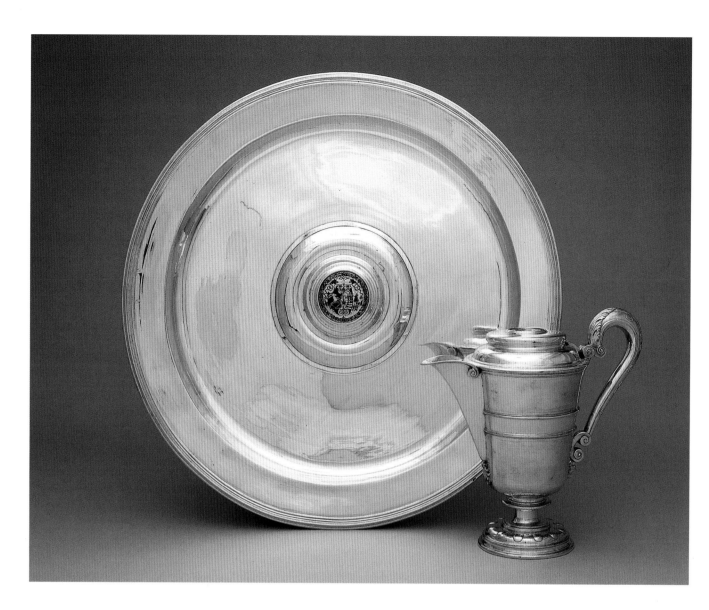

17 Ewer and Basin
 German (Augsburg), 1583
 By Abraham Pfleger I
 (Augsburg, active from 1558–
 died 1605)

 Parcel gilt silver with enameled plaques
 and engraving
 (Ewer)
 Height: 25 cm (9¹³⁄₁₆ in.)
 (Basin)
 Diameter: 50.5 cm (19⅞ in.)
 85.DG.33.1–.2

Pfleger was one of the most prominent and gifted silversmiths in late-sixteenth-century Augsburg. Although he was often employed by important patrons, few of his works survive. This ewer and basin served to offer scented water to guests at the dining table so that they could wash their hands between courses. The set was commissioned to commemorate an alliance between the Fuggers, the most illustrious of all German banking families, and the Palffy von Erdöds, a famous ancient Hungarian family. It is known from documents of the *Hofkammer* (the court's archive in Vienna) that Pfleger executed two sets of a ewer and basin on the occasion of the marriage of Maria Fugger to Duke Nikolaus Palffy von Erdöd in 1583. The unusually restrained and formally severe style of the Getty ewer and basin is perfectly in keeping with Pfleger's other known works, indicating that this set must be one of the two mentioned in the archive.

18 Pilgrim Flask
(*Fiasca da Pellegrino*)
Italian (Florence),
circa 1575–1587
Made in the Medici
porcelain factory

Soft-paste porcelain
Height: 26.5 cm (10⅜ in.)
Max. width: 20 cm (7⅞ in.)
Diameter (at lip): 4 cm (1⁹⁄₁₆ in.)
86.DE.630

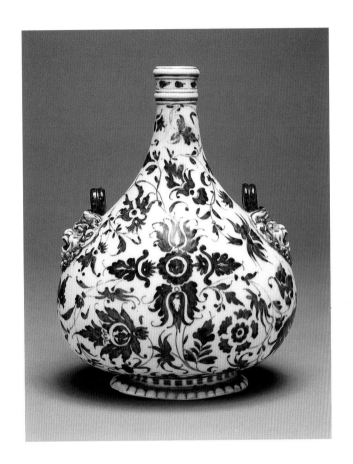

This flask is one of the earliest examples of porcelain produced in Europe. By the late sixteenth century, maiolica wares had begun to decline in popularity among the affluent. In response to both the increasing passion for Chinese porcelain and the continuing demand for novelty, porcelain came to dominate the market for luxurious ceramics.

This flask is one of the exceedingly rare objects produced in the Medici factory, roughly sixty of which remain today. The factory had been established by Grand Duke Cosimo I to encourage such sophisticated arts as crystal carving, tapestry weaving, and porcelain production. It was under the direction of Cosimo's son, Francesco I, that porcelain was finally made successfully. Porcelain production apparently continued for a few decades after Francesco's death in 1587, after which, surprisingly, almost a century passed before soft-paste porcelain was revived in France at Rouen—by Louis Poterat in 1673—and later at Saint-Cloud.

The Museum's flask is an exceptionally beautiful example of Medici porcelain, displaying a well-formed white body with clear, deep blue designs. The arabesque patterns and stylized floral decoration—including rose, carnation, tulip, and palmette motifs—are derived from Turkish Iznik ware dating from around 1500.

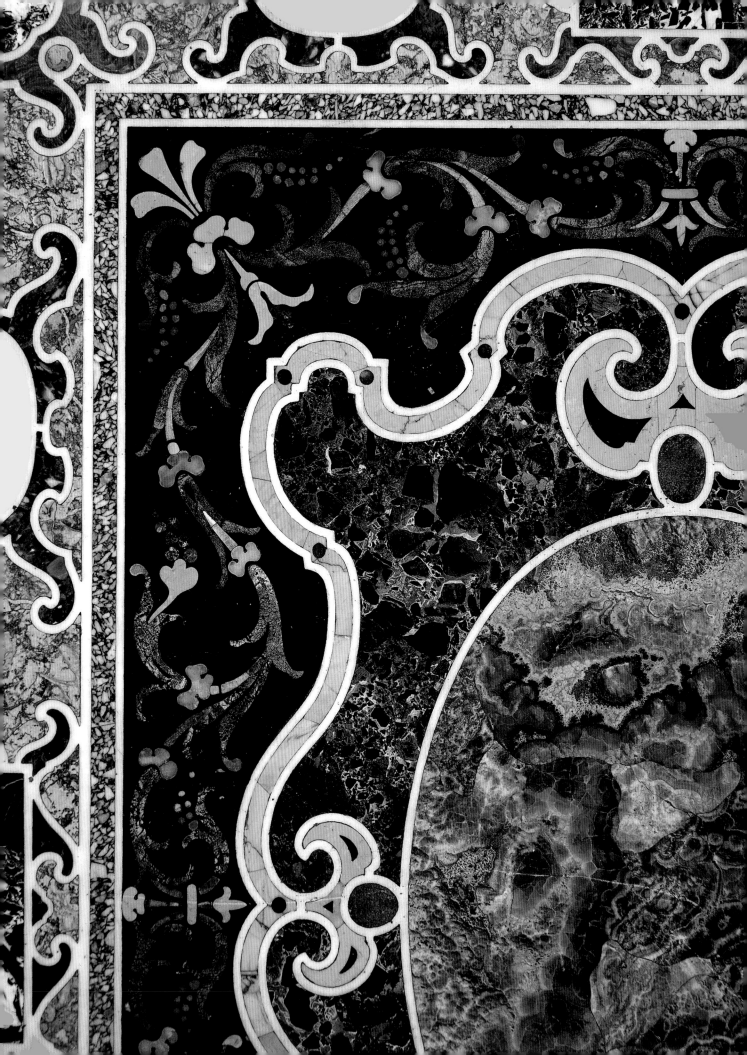

19 Tabletop
 Italian (Florence or Rome),
 circa 1580–1600

Pietre dure and marble *commesso,*
including *breccia di Tivoli* (or
Quintilina), *giallo antico, nero antico,
breccia rossa, breccia cenerina, breccia
verde, broccatello, bianco e nero antico,*
serpentine, alabaster *fiorito,* alabaster
a tartarugo, lapis lazuli, coral, rock
crystal, and yellow and black jasper
Width: 136.5 cm (53¾ in.)
Depth: 113 cm (44½ in.)
92.DA.70

Detail at left

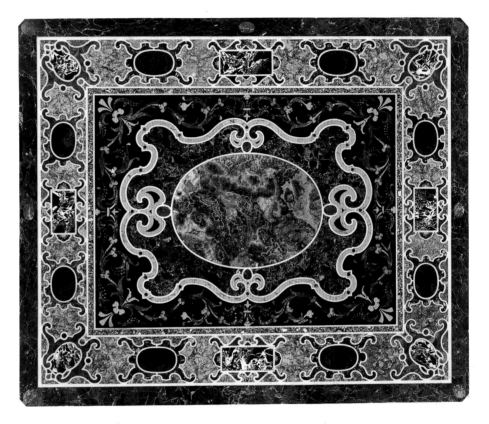

Hard- and softstone *commesso,* a jigsaw-puzzle-like mosaic technique, flourished in
ancient Greece and Rome and was revived in Renaissance Italy, particularly in Florence
and Rome. In early Renaissance examples geometric patterns predominate, but by the
end of the sixteenth century, as the demanding technique was mastered, artists began
to include more pictorial elements, such as the scrolling foliage on this tabletop. Each
decorative component is outlined in white marble, which sets off the richly colored
and patterned elements from one another and emphasizes the table's jewel-like quality.

 This tabletop must have been produced after 1559, since the *breccia di Tivoli* of
the top was only discovered in the ruins of the ancient Villa di Quintiliolo at Tivoli
when Cardinal Innocenzo del Monte was transferred there during the papacy of Pius
V (r. 1559–1565).

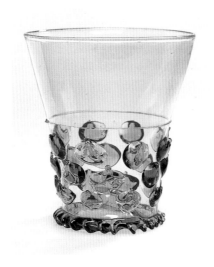

Calcedonio, or chalcedony, glass was invented on the Venetian island of Murano in the late fifteenth century. The invention of this opaque glass is credited to the only fifteenth-century Venetian glassmaker who can today be named, Angelo Barovier. Barovier, born into a glassmaking family active in Murano since 1330, may have also developed the recipe for *cristallo,* the thin and clear glass resembling rock crystal that led to the Renaissance style in Venetian glassmaking. The marbled appearance of *calcedonio* glass is achieved by mingling different metallic oxides into the glass before shaping the object. The resulting effect of blue, green, brown, and yellow swirls recalls the highly prized cut-hardstone vessels developed in ancient Rome and revived in Renaissance Italy.

20 Footed Bowl (*Coppa*)
 Italian (Murano), circa 1500

 Free-blown *calcedonio* glass
 Height: 12.3 cm (4⅞ in.)
 Diameter (at lip): 19.7 cm (7¾ in.)
 Diameter (at base): 10.6 cm (4³⁄₁₆ in.)
 84.DK.660

21 Prunted Beaker (*Berkemeyer*)
 South German (Lower Rhenish)
 or possibly the Netherlands,
 circa 1500–1550

 Free-blown potash-lime glass
 with applied decoration
 Height: 13.5 cm (5⁵⁄₁₆ in.)
 Diameter (at lip): 12.9 cm (5¹⁄₁₆ in.)
 Diameter (at base): 8.5 cm (3⅜ in.)
 84.DK.527

This popular form of German drinking glass dates from the late fifteenth century and continues to be made today. These beakers were made of *Waldglas,* or forest glass, so called because it was produced in rural workshops located in forests where there were plentiful supplies of wood fuel for the glass furnaces. The characteristic green color of most *Waldglas* was caused by iron-rich impurities in the local sand, the most common form of silica used in the production of this glass. Because of their popularity and aesthetic appeal, forest-glass beakers continued to be made even after German glassmakers were capable of producing colorless glass.

The *Berkemeyer* is a funnel-shaped variation of the more spherical *Römer,* whose name may derive from the Lower Rhenish *roemen,* "to boast," since boasting may have easily followed the consumption of alcoholic drink. The Getty example is an early type in which the bowl and stem are essentially one conical element. The hollow stem is covered with "prunts," or blobs of glass, that serve to provide a secure grip.

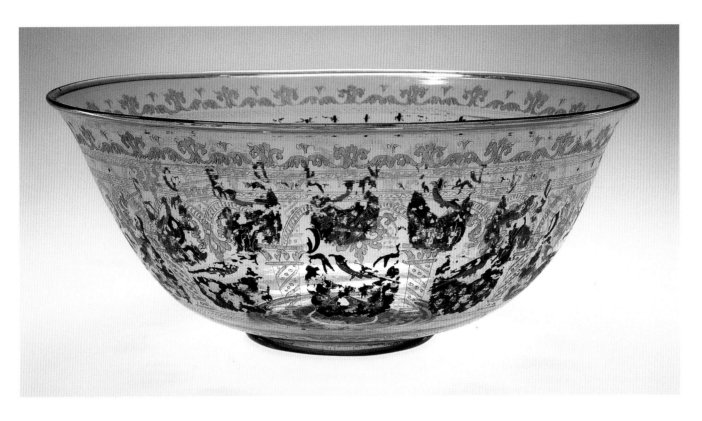

22 Bowl
Probably Austrian (Innsbruck),
circa 1570–1591

Colorless soda glass with diamond-
point engraving, gilding, and cold-
enamel decoration
Height: 16 cm (6⁵⁄₁₆ in.)
Diameter (at lip): 40.4 cm (15¹⁵⁄₁₆ in.)
Diameter (at base): 13.5 cm (5⁵⁄₁₆ in.)
84.DK.653

This bowl is the largest and best preserved of only four related examples that are documented. The technique of diamond-point engraving—used here for the foliate banding, the arcaded columns, and the swags—was developed in Murano in the mid-sixteenth century and introduced in the Tirol, at Hall and Innsbruck, around 1570. Some of the bowl's decorative motifs, such as the palmette frieze, are found on objects produced in both Tirolean towns; however, it is thought that the Getty bowl was made at the Innsbruck *Hofglashütte,* or Royal Glasshouse, because of similarities between this work and other pieces attributed to Innsbruck or known to have belonged to Archduke Ferdinand II, who founded the glasshouse in 1563.

Cold-painted enamel and gold—used to embellish the fruit and foliate swags and for the goldfinches sitting on them—is a technique in which the painting is applied without undergoing a subsequent firing that would adhere it to the glass surface. As a result, much cold-painting of this type wears off over time. In some cases, the practice of cold-painting might have been used for exceptionally large vessels, such as this bowl, which could not withstand (or perhaps fit into) the muffle furnace for fusing the enamels to the glass.

23 Standing Covered
 Filigrana Cup
 Glass: German or Italian
 (Murano), late sixteenth–early
 seventeenth century
 Mounts: German (Augsburg),
 1615–1625

Free- and mold-blown soda glass,
lattimo threads, and silver-gilt mounts
Height (with lid): 21.1 cm (8⁵⁄₁₆ in.)
Height (without lid): 14.5 cm (5¹¹⁄₁₆ in.)
Diameter (at lip): 5.8 cm (2¼ in.)
Diameter (at base): 9.4 cm (3¹¹⁄₁₆ in.)
84.DK.514.1–.2

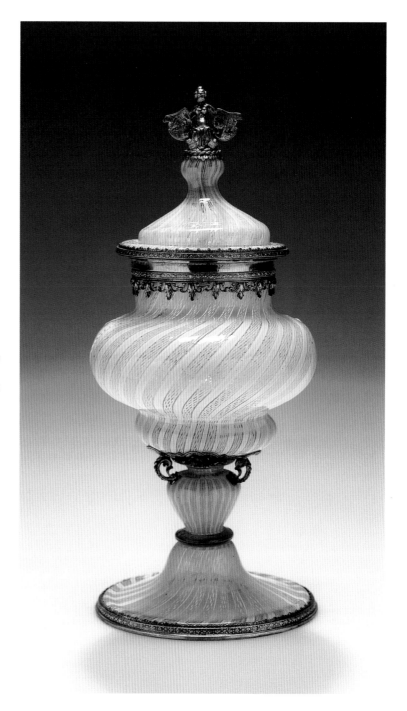

This is one of only two known mounted vessels of comparable form (the other being
in the Lehman Collection at the Metropolitan Museum of Art, New York). This
example of filigree glass, with its "twisted-thread" decoration, appears to have been
made in Murano and exported to Germany to be mounted many decades later. The
lip of the cover bears the maker's mark of Mattäus Wallbaum (1554–1632), who
produced mounts for various objects—including reliquaries, jewelry boxes, and
clocks—but very few for glass. Also on the lip is the punchmark for the city of
Augsburg dating to 1615–1625, indicating either that this type of Venetian glass
was so highly prized that it was carefully kept for later mounting or that this type
of vessel continued to be made well into the seventeenth century.

24 *Filigrana* Bottle (*Kuttrolf*)
Italian (Murano), late sixteenth
–early seventeenth century

Free- and mold-blown soda glass,
with *lattimo* threads
Height: 23.9 cm (9⅜ in.)
Diameter (at base): 7.2 cm (2¹³⁄₁₆ in.)
84.DK.661

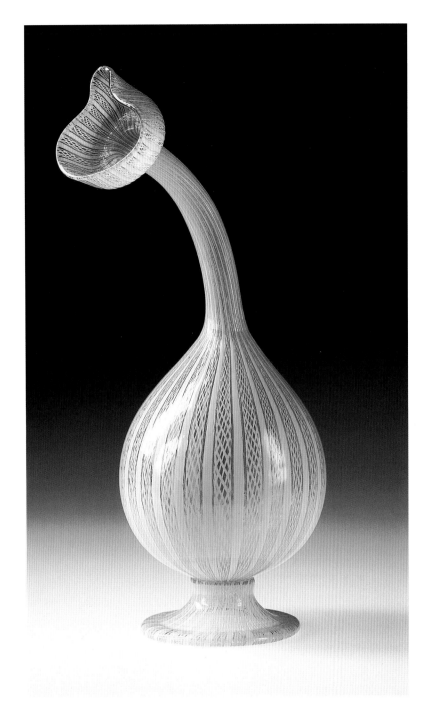

Like the preceding cup (no. 23), this bottle is made of a type of filigree glass called
vetro a retorti. The piece's curious yet elegant shape was inspired by Syrian glass bottles
of the fourth century, whose function may have been to drizzle perfume. Revived
in Europe in the fifteenth century, these bottles were occasionally used for drinking,
although their narrow, often twisted necks made for slow pouring and dripping. The
name *Kuttrolf* may derive from *gutta* (Latin for "drop of liquid") or from *Kuttering*
(German for "gurgling"). Indeed, this auditory aspect may well have been appreciated
as a sensual pleasure to enhance the enjoyment of a meal.

25 *Portrait of Pope Clement VIII (Ippolito Aldobrandini)*
Italian (Florence), 1600–1601
Designed by Jacopo Ligozzi (Verona, circa 1547–1626); produced in the *Galleria de' Lavori in Pietre Dure;* executed by Romolo di Francesco Ferrucci, called del Tadda (Florence, died 1621)

Calcite, lapis lazuli, mother-of-pearl, limestone, and marble on and surrounded by a silicate black stone, with a gilt-bronze frame
Height (with frame): 101.7 cm (40¹⁄₁₆ in.)
Width (with frame): 75.2 cm (29⅝ in.)
Height (without frame): 97 cm (38³⁄₁₆ in.)
Width (without frame): 68 cm (26¾ in.)
92.SE.67

Pictorial representations in stone mosaic had been popular in ancient Greece and Rome; interest in the medium was revived in Renaissance Italy, where it was prized for its permanence and "ingenious artifice." Hard- and softstone *commessi* (see nos. 10 and 19) were fostered in the Medici court, particularly by Ferdinando I, Grand Duke of Tuscany, who founded the court workshop in which local craftsmen could be trained in the revered and demanding stone technique. Portraits in this medium, however, are exceedingly rare, with this being one of only two surviving works from a group of four that were known to have been produced at the time.

From documents, we know that Ferdinando gave Pope Clement VIII this portrait in 1601, possibly in connection with the marriage at the turn of the century of Maria de' Medici, Ferdinando's niece, to Henri IV, King of France. The pope's image has an eerie presence that is partly due to the luminescence of the stones, which were thought, moreover, to possess intrinsic powers. The strength of the sitter is further emphasized by showing him in the triple-crowned tiara, symbol of his authority and high ecclesiastical office.

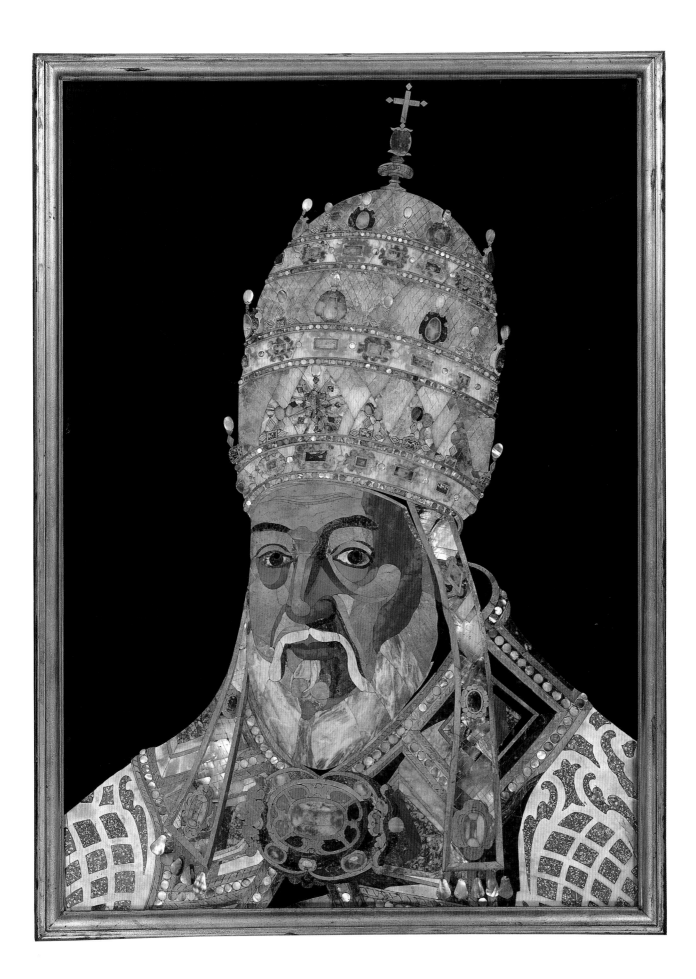

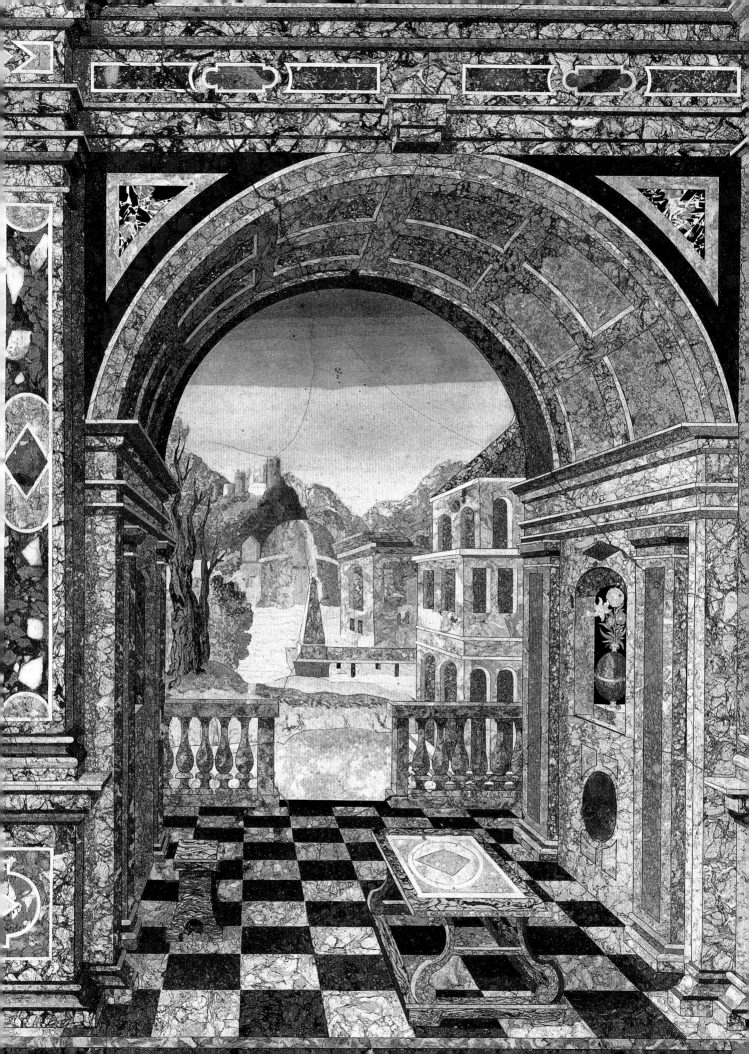

26 Architectural Scene and Frame
 South German, circa 1630–1670
 Plaque: Workshop of Blausius
 Fistulator (Munich, active
 1587–1622)

Scagliola
Height: 43.5 cm (17⅛ in.)
Width: 50 cm (19¹¹⁄₁₆ in.)
Frame: Italian, circa 1730–1740
Ebonized wood with gilt-bronze
mounts
Height: 73 cm (28¾ in.)
Width: 67 cm (26⅜ in.)
92.SE.69

Detail at left

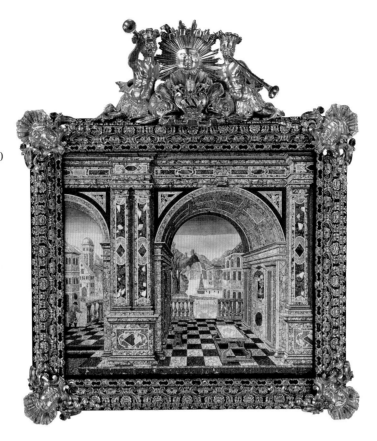

Scagliola was first developed in South Germany at the end of the sixteenth century as
a less expensive and less time-consuming alternative to *pietre dure* inlay. The technique
involved attaching a type of gypsum—which had been pulverized and pigmented—to a
wet gesso ground. The surface was then highly polished to imitate the gloss of polished
hard- and softstones.

 The picturesque Italianate scene on this plaque (see detail at left) was inspired
by perspective prints and stage-set designs published in the sixteenth and seventeenth
centuries. It most closely relates to the work of Blausius Fistulator and his followers,
who created a number of similar plaques for the Munich Residenz.

 Nearly a century after it was made, this plaque was placed in its present frame,
which is exuberantly conceived with eighteenth-century ornament reminiscent of the
work of the Florentine sculptor and designer Giovanni Battista Foggini (1652–1725).
The whole is surmounted by the coat of arms of Lorenzo Corsini (1652–1740), who
was elected Pope Clement XII in 1730. It is not known, however, whether the pope
himself had the object framed or whether it was framed in order to be presented to
him as a gift.

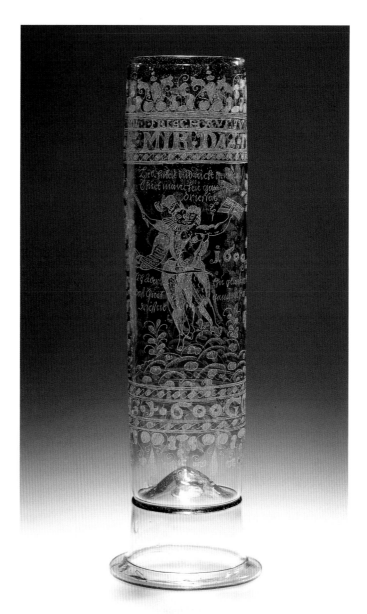

27 Footed Beaker (*Stangenglas*)
Southern Bohemian, 1600

Free-blown potash-lime glass
with diamond-point engraving
Height: 34.5 cm (13⁹⁄₁₆ in.)
Diameter (at lip): 8 cm (3⅛ in.)
Diameter (at base): 10.7 cm (4¼ in.)
84.DK.559

This is one of the finest examples of a glass engraved with figurative subject matter, in this case depicting particularly lascivious scenes with great precision and even delicacy. On one side, a naked woman holds aloft a sheet of music and a conductor's baton. A clothed man behind her, who is grabbing her breast with his left hand, draws a large bow across her as if she were a stringed instrument. On the other side, another naked woman stands holding the bushy tail of a fox between her legs, with a dog, his tongue hanging out, looking up at her. These subjects, which may derive from local prints, are not uncommon examples of the kind of sexual innuendo and symbolism that were popular in the North.

The term *Stangenglas* derives from the German word for "pole" or "stalk," an appropriate name given the vessel's tall and narrow shape. These vessels were used for the consumption of alcoholic beverages, especially beer; the association of drunkenness with carnal pleasure is a familiar one.

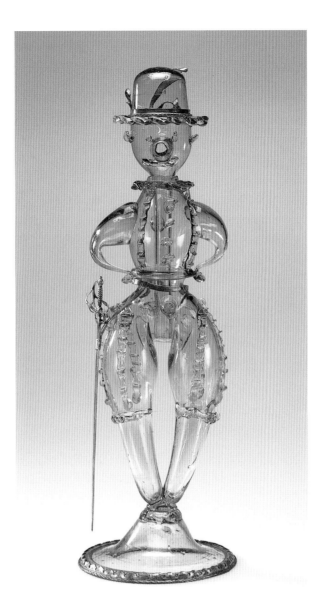

28 Joke Glass (*Scherzgefäss*)
German or Netherlandish,
seventeenth century

Free-blown potash-lime glass with
applied decoration and silver mounts
Height: 33.7 cm (13¼ in.)
84.DK.520.1–.2

This rare glass, a tour de force of glassblowing, was designed to be as difficult as
possible to drink from without spilling the alcoholic beverage within. The tube
attached to the head and terminating in the figure's open nose could serve as a straw.
The goal was to amuse the onlookers at the expense of the imbiber: in drinking
competitions, if any liquor was spilled, the drinker was required to start again with
a full glass.

 This example is one of only two known joke glasses resembling a man. These
glasses more commonly took the form of a stag or other animal, boot, pistol, phallus,
or horn.

29 Standing Covered Cup
 German, 1631
 By Marcus Heiden
 (Coburg, active from at least
 1618 – died after 1664)

 Lathe-turned and carved ivory
 Height: 63.5 cm (25 in.)
 91.DH.75

 Detail at right

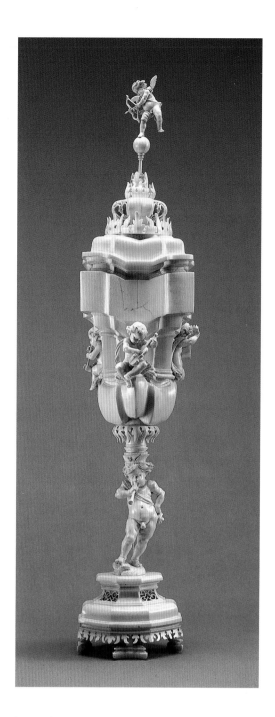

Turned ivories—ivories worked on a lathe to create varying geometric forms—were popular among the princely collectors of Europe, and Marcus Heiden was one of the technique's greatest practitioners. Heiden, who signed and dated this object under its base, created decorative and functional ivory objects for the court of Saxony, and this work was probably made for Duke Johann Casimir of Saxe-Coburg.

Stylistically, the goblet is typical of early-seventeenth-century turned ivories in which a combination of sculpted figural and lathe-turned abstract forms seem to rotate around a dynamic, shifting axis. The unusual, and probably later, addition of corpulent infants in playful poses further enhances the sense of movement; for example, the trumpet-blowing infant supporting the body of this display vessel (see detail at right) thrusts out his hip, heightening the impression of precarious balance.

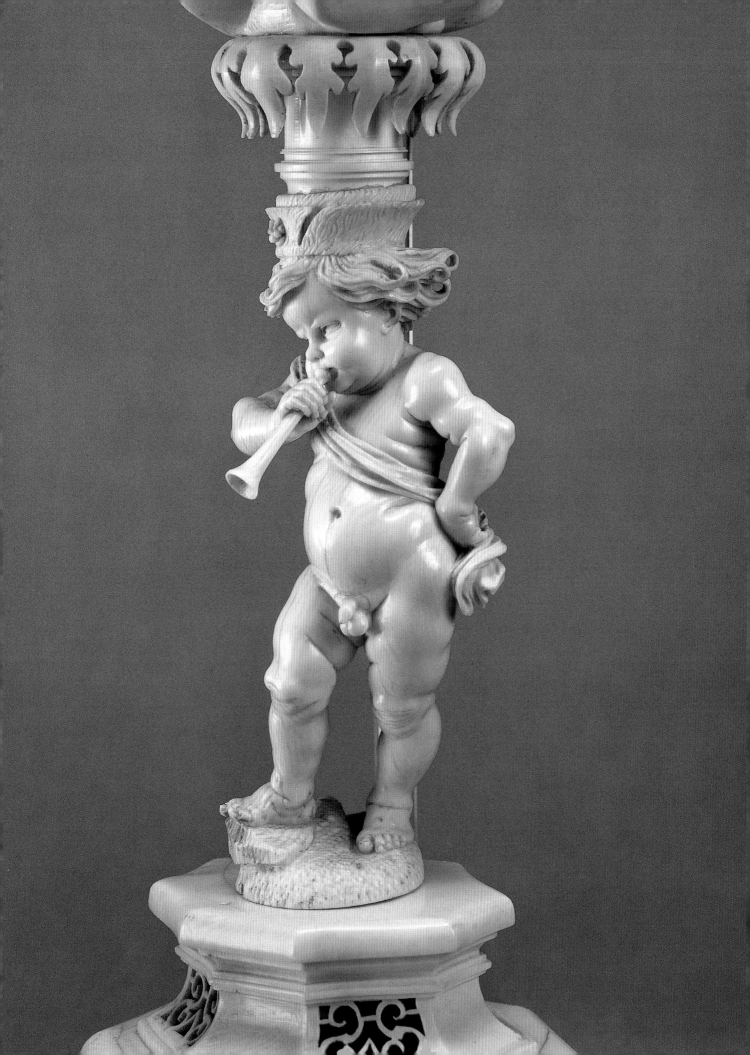

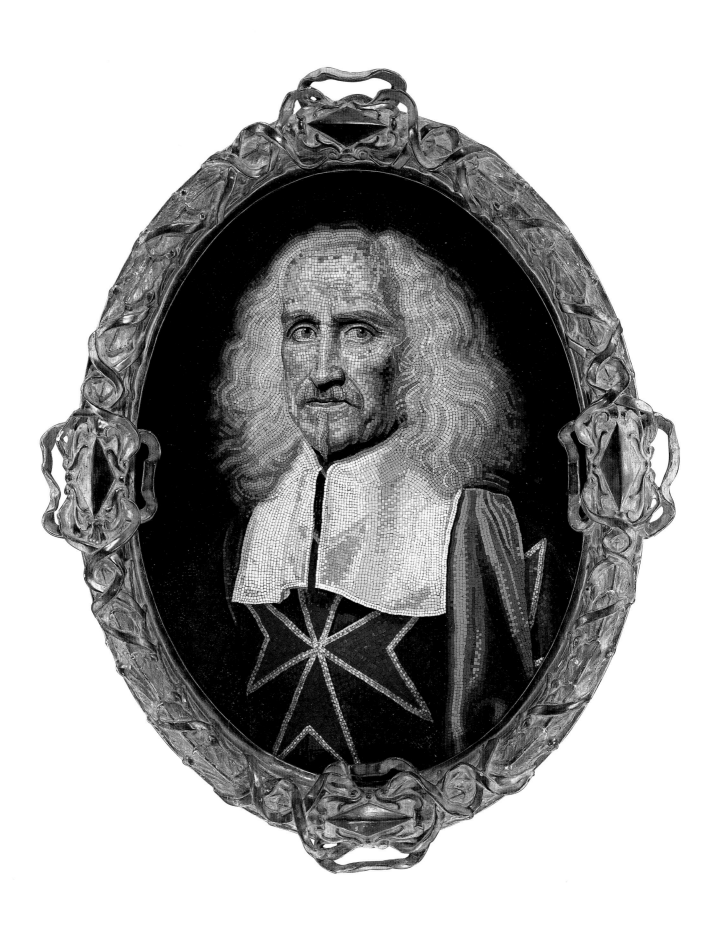

30 *Portrait of Camillo Rospigliosi*
Italian, 1630–1640
Attributed to Giovanni Battista
Calandra (Vercelli, active in
Rome; 1586–1644)

Ceramic tile mosaic in a gilt-wood
frame
Height (without frame): 62 cm
(24⅜ in.)
Width (without frame): 48.5 cm
(19¹⁄₁₆ in.)
87.SE.132

This mosaic portrait depicts Camillo Rospigliosi, brother of Pope Clement IX (1600–1669) and Knight Commander of the Order of Santo Stefano, whose cross insignia he wears. Giovanni Battista Calandra was perhaps the greatest mosaic artist active in early-seventeenth-century Rome, and his work was much sought after among contemporary noble and papal families.

Seventeenth-century mosaics were appreciated not only as architectural decoration but also as "eternal" imitations of paintings. Calandra likely copied a portrait by one of his contemporaries—such as Andrea Sacchi or Guido Reni—whose paintings share the expressive style of this mosaic. By skillfully piecing together small ceramic tesserae, Calandra reproduced the pictorial effects of perspective and colorism, rendering his subjects with great acuity. The depiction of the cross seen through the sitter's fabric collar is a notable tour de force.

31 Display Cabinet (*Toonkast*)
Flemish (probably Antwerp),
circa 1630

Oak, walnut, and boxwood;
veneered with fruitwood, amaranth,
king ebony, and tortoiseshell
Height: 210.2 cm (82¾ in.)
Width: 158 cm (62¼ in.)
Depth: 74.5 cm (29⅜ in.)
88.DA.10

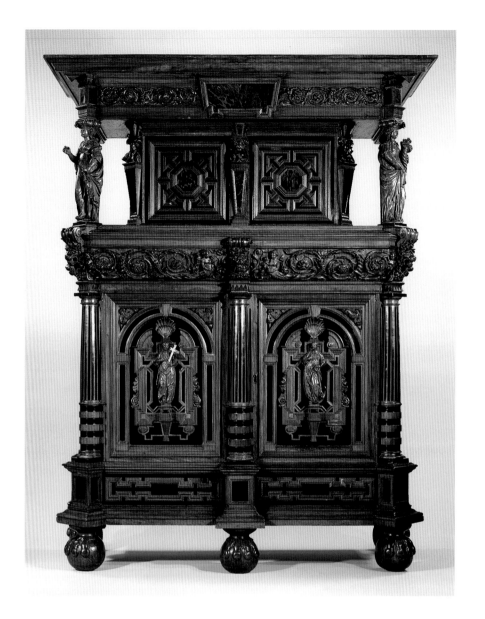

This cabinet inventively combines architectural forms with elegantly sculpted figures. The forms were likely influenced by published studies, including those of Du Cerceau, Sebastiano Serlio, Giovanni da Brescia, and Paul Vredeman de Vries; the figures recall the work of such Northern painters as Lucas van Leyden, Crispijn de Passe de Oude, Cornelis Massys, and Albrecht Dürer. The two doors in front are decorated with allegorical figures of two of the three Theological Virtues: Faith and Hope hold their respective attributes of a cross and an anchor. On the central drawer, the third Virtue, Charity, is shown suckling infants. Five "term" figures (that is, heads of men and women resting on quadrangular pillars) decorate the receding cupboard behind the four caryatids. These term figures—shown engaging in drinking, playing music, and other forms of enjoyment—may depict the five senses, while the beautifully sculpted caryatids appear to represent the four seasons.

The owner would have used this cabinet to keep his precious household objects, a worldly function symbolized by the representation of the five senses on the piece. The presence of the Theological Virtues, however, may have served as a reminder that pleasure must not take precedence over Christian principles.

32 Display Cabinet
 (*Kabinettschrank*)
 German (Augsburg),
 circa 1620–1630

Ebony, pearwood, oak, boxwood,
walnut, chestnut, marble, ivory,
semiprecious stones, tortoiseshell,
palm wood, enamel, and miniature
painting
Height: 73 cm (28¾ in.)
Width: 58 cm (22¹³⁄₁₆ in.)
Depth: 59 cm (23¼ in.)
89.DA.28

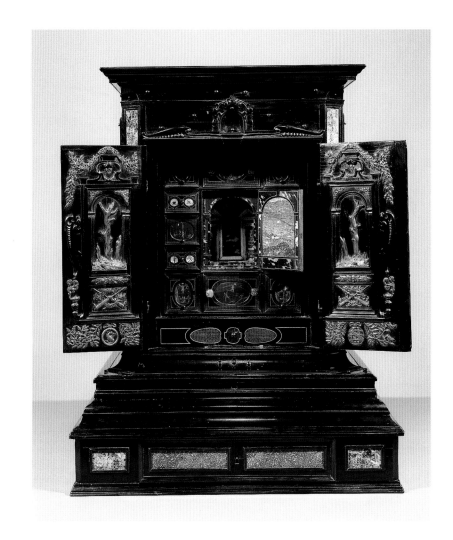

The architectural form of this piece and the curvilinear ornament above the doors on
the front correspond to a type of cabinet that was produced in Augsburg in the first
decades of the seventeenth century. Its unknown maker was undoubtedly influenced
by the projects of Ulrich Baumgartner (1579–1652), arguably the greatest Augsburg
cabinetmaker of the period. Various masters would have executed the cabinet's
diverse embellishment, though only one can be named: the Dutch carver Albert
Jansz. Vinckenbrinck signed several of the fruitwood reliefs on one side with his
monogram, *ALVB*.

 The exterior, of elegantly restrained proportions and decoration, opens to reveal
a surprisingly complex series of drawers and compartments that are richly decorated
in a variety of materials and techniques depicting biblical, allegorical, historical, and
mythological subjects. The preponderance of subjects concerned with the power of
women (such as Christ and the woman of Samaria, and Phyllis and Aristotle) may have
served a cautionary or moralizing function. The religious themes express a concern for
Christian virtue that may have also served as a righteous admonition in light of the
cabinet's worldly function: the storage and display of the collector's precious objects.

33 Basin
 Italian (Dutch or Flemish artist
 working in Genoa), 1620–1625
 After a design by Bernardo
 Strozzi (Genoa, 1581–1644)

Silver
Diameter: 75.5 cm (29¾ in.)
85.DG.81

Detail at right

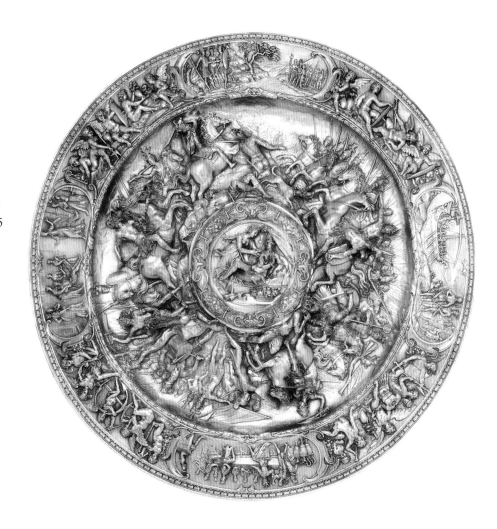

This basin depicts episodes from the story of Antony and Cleopatra, possibly derived from Plutarch's *Lives*. In cartouches around the rim are the scenes of the formation of the Triumvirate, when Antony meets with Octavian and Lepidus; Cleopatra's first meeting with Antony as she is transported up the Cydnus River; a banquet scene; and the death of Antony. The main battle scene, sculpted in remarkably high relief, with some figures cast in the round and then attached, may be the Battle of Actium. The central boss (see detail at right) depicts the scene of Cleopatra's death: she has taken the asp from the basket of figs at her side as her maidservant rushes to her aid.

The design is closely based on an oil sketch of about 1625 by the Genoese painter Bernardo Strozzi (Ashmolean Museum, Oxford). The style of the figures and animals suggests that a Dutch or Flemish silversmith, working in Genoa, translated the sketch into precious metal.

This elaborately molded basin served as a display piece rather than as a functional vessel. It might well have been designed with a matching ewer, now lost; ewer and basin would have presented a spectacular display of the silversmith's art. The basin is the largest and most important piece of secular silver of the period.

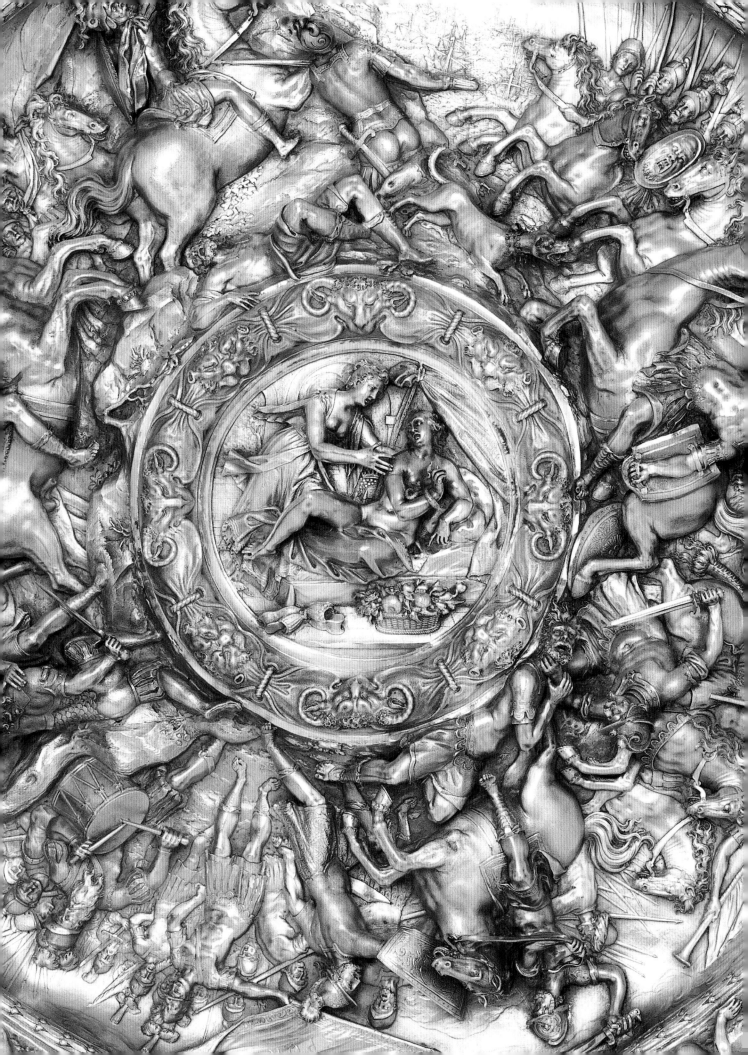

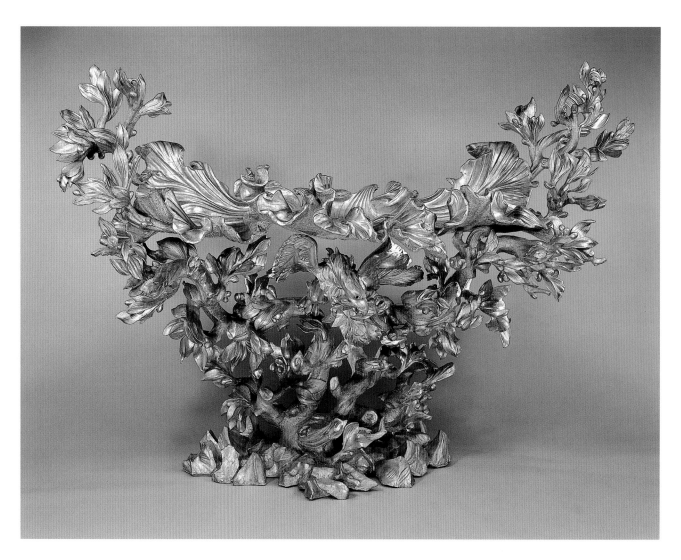

34 Side Table
 Italian (Rome), circa 1670
 Attributed to Johann Paul Schor,
 called Giovanni Paolo Tedesco
 (Innsbruck, active in Rome;
 1615–1674)

 Carved and gilt poplar
 Height: 170 cm (66¹⁵/₁₆ in.)
 Width: 225 cm (88½ in.)
 Depth: 85 cm (33⁷/₁₆ in.)
 86.DA.7

This remarkable table, hardly functional given its highly sculptural form, was probably used for the ostentatious decoration of a Roman *palazzo*. It is sculpted in the form of a laurel trunk surrounded at the base by rocks and sprouting leaves and berries. An eagle is set within the branches, and the top is carved in the shape of a large seashell. Although these images represent Baroque subjects and allegories, they may also contain some as-yet-unidentified heraldic significance.

A versatile artist, Johann Paul Schor designed gardens, festival decorations, state furniture, ecclesiastic and decorative objects, and fountains. Throughout the 1660s, he worked steadily for Bernini, with whom he collaborated on the Throne of Saint Peter in the Vatican. Schor's mature work prefigures the transition from the seventeenth to the eighteenth century, displaying not only the animated and curvilinear style typical of the Baroque but also the later taste for picturesque fictive ruins and grottoes. The attribution of this table to Schor is also based on the stylistic similarities between the table and the artist's drawings and engravings for elaborate pieces of sculptural decorative arts, including several coaches and a bed.

35 One of a Group of Ten Panels
French (Paris), circa 1661
Attributed to Charles Le Brun
(1619–1690)

Painted and gilded oak
Height: 213 cm (83⅞ in.)
Width: 79 cm (31⅛ in.)
91.DH.18.1–.10

This is one panel from a group of ten that probably once formed part of a larger assemblage. The panels would have been set close together and would have been installed in a room of considerable grandeur. They correspond very closely in style to similar panels in the château of Vaux-le-Vicomte near Paris; one is painted with precisely the same motifs as those on a panel that still remains in the *antichambre du roi* (now the library) there. Charles Le Brun was responsible for the decoration of Vaux-le-Vicomte, and he and members of his atelier carried out the work.

The panels are designed in the elaborate late Baroque style developed by Le Brun for interior decoration in the mid-seventeenth century to promote the grand aspirations of members of the aristocracy during the youth of Louis XIV. The four largest panels bear oval paintings in grisaille of seated women in classical dress representing the four Cardinal Virtues: Fortitude, Prudence, Temperance, and Justice.

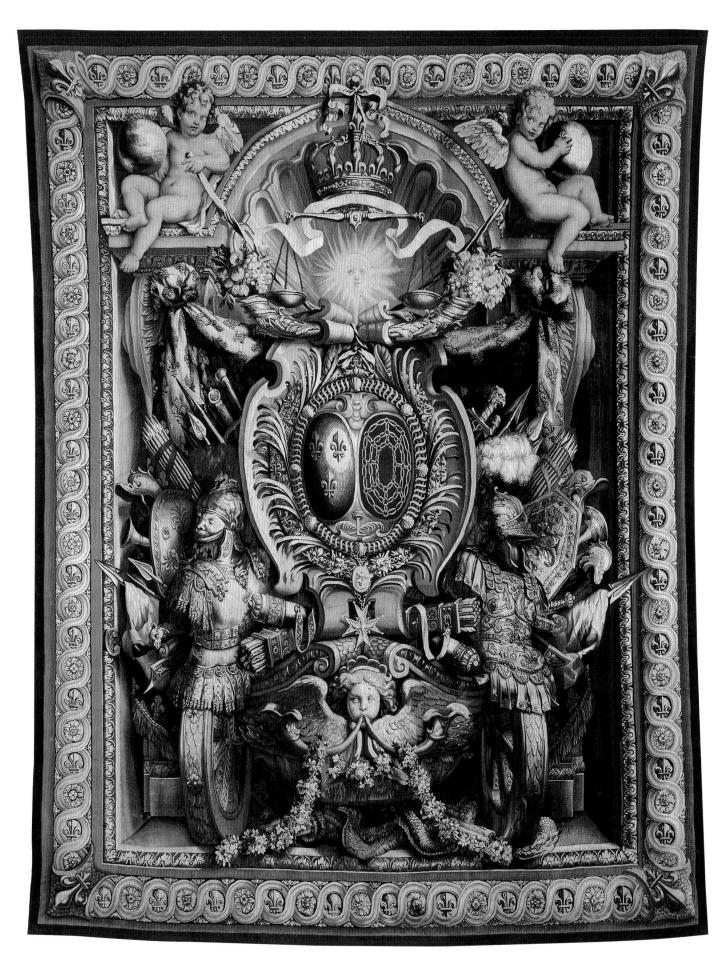

36 Tapestry:
 "Portière du Char de Triomphe"
 French (Paris), circa 1699–1717
 Woven at the Gobelins
 manufactory in the workshop
 of Jean de la Croix *père*
 (*entrepreneur* at the Gobelins,
 1662–1712), Jean de la Faye
 (circa 1655–1730), or Jean
 Souet (circa 1653–1724), after
 a cartoon designed by Charles
 Le Brun (1619–1690) and
 painted by Beaudrin Yvart *père*
 (1611–1680)

 Wool and silk; linen; modern
 linen lining
 Height: 357.5 cm (140¾ in.)
 Width: 277.8 cm (109⅜ in.)
 83.DD.20

As *portières* served the practical function of hanging over doorways to block drafts and provide privacy, their frequent appearance and prominent placement made them suitable for displaying heraldic arms in royal residences. This example represents the arms of the king of France and Navarre carried in a triumphal procession on a chariot filled with military trophies.

 This *portière* was one of six delivered in 1717 to the royal household, and it still bears its original inventory number of 194. Tapestries of this design were used in the royal château until 1792, an indication of the conservative tastes that often prevailed at court.

37 Carpet
 French (Chaillot), 1665–1667
 Made in the Savonnerie
 workshop of Simon Lourdet
 (born circa 1595–died 1667?)
 and Philippe Lourdet (died 1671;
 active before 1664–circa 1670)

 Wool and linen; modern cotton lining
 Length: 670.5 cm (264 in.)
 Width: 440 cm (173¼ in.)
 70.DC.63

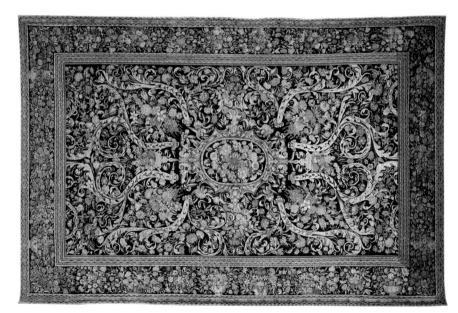

The manufactory of Savonnerie, located just outside the city of Paris, was active from the seventeenth century onward, working primarily for the French crown. It produced carpets, bench covers, and panels for folding screens of knotted wool pile in a technique that imitated carpets made in the Near East, particularly Turkey and Persia. This example combines patterns of floral arrangements reminiscent of the medieval *millefleur* pattern with large acanthus leaf scrolls. Around the border are images of blue and white porcelain bowls representative of the Ming wares imported from China during the seventeenth century.

38 Reading and Writing Table
 French (Paris), circa 1670–1675

Walnut and oak veneered with ivory,
ebony, blue painted horn and
amaranth; gilt-bronze moldings; steel;
modern silk velvet
Height: 63.5 cm (25 in.)
Width: 48.5 cm (19⅛ in.)
Depth: 35.5 cm (14 in.)
83.DA.21

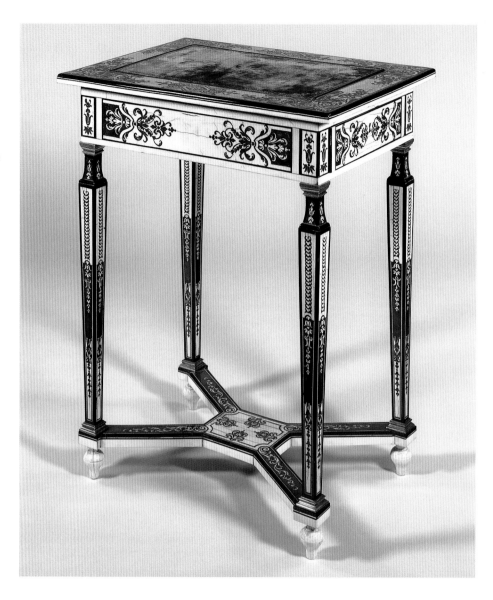

The top of this small table may be raised to form an angled reading or writing stand, while a drawer at the side is fitted for writing equipment. It is described in considerable detail in the posthumous inventory of 1729 of the possessions of Louis XIV.

Unfortunately the name of the maker is not given, nor its previous location. It is possible that the table was made for the famous mistress of Louis XIV, Madame de Montespan, for use in the Trianon de Porcelaine that was built for her at Versailles in 1670. This small pavilion was decorated with blue and white ceramic tiles, and some of the furniture was painted blue and white "à la façon de porcelaine," following the fashion of the time for all things oriental, especially blue and white Chinese vases. The building was pulled down in 1687, to be replaced by the Grand Trianon.

This table, the earliest piece of French furniture in the collection, is of great rarity.

39 Table
French (Paris), circa 1675
Attributed to Pierre Golle
(circa 1620–1684; master before
1656)

Oak veneered with tortoiseshell, brass,
pewter, and ebony; gilt bronze and gilt
wood, with ebony drawers
Height: 76.7 cm (30½ in.)
Width (closed): 42 cm (16½ in.)
Depth: 36.1 cm (14¼ in.)
82.DA.34

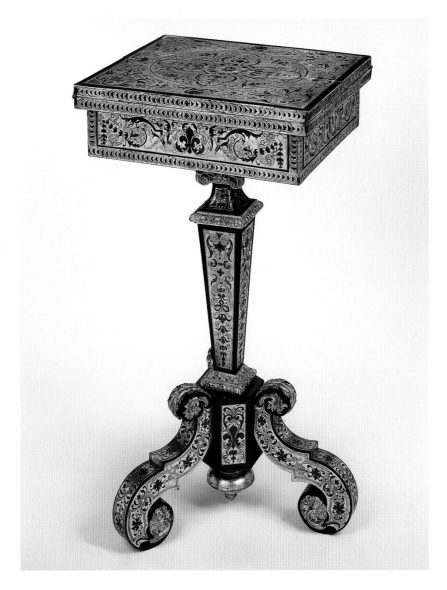

The top of this table unfolds to reveal a scene showing three women in oriental dress taking tea under a canopied tent. The table, supported by a tripod, was certainly intended to hold a tray with tea bowls, in keeping with the theme of the decoration.

It is probable that the table was made for Louis XIV's son, the Grand Dauphin (1661–1711). It bears on the frieze and on the stand four prominent fleurs-de-lys, the heraldic lily from the royal arms of France, and, on the foldout flaps, large dolphins in tortoiseshell, the emblem of the Dauphin.

The pair to this table is in the British Royal Collection, where it has been since the early years of the nineteenth century.

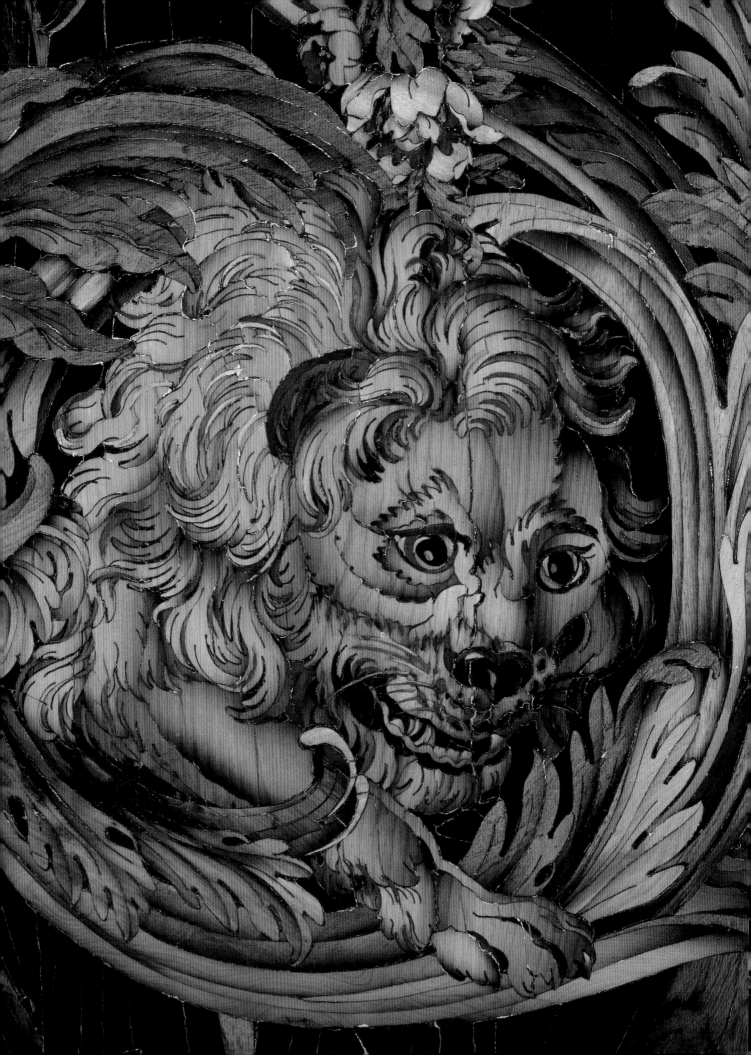

40 Cabinet on Stand
French (Paris), circa 1680
Attributed to André-Charles
Boulle (1642–1732;
master before 1666)

Oak veneered with tortoiseshell, brass,
pewter, horn, ebony, and ivory, with
marquetry of stained and natural
woods; bronze mounts; figures of
painted and gilded oak; drawers of
snake wood
Height: 229.9 cm (90½ in.)
Width: 151.2 cm (59½ in.)
Depth: 66.7 cm (26¼ in.)
77.DA.1

Detail at left

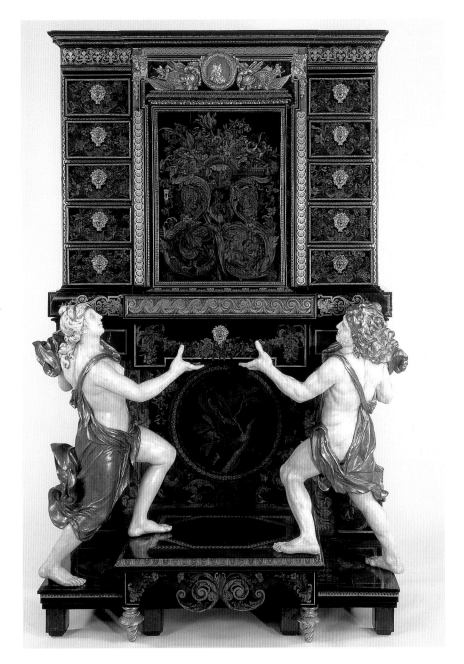

The decorative scheme of the cabinet refers to Louis XIV's military victories; the
central door is decorated with a panel of marquetry showing the cockerel of France
standing triumphant over the lion of Spain and the eagle of the Holy Roman Empire.
The cabinet was probably made in recognition of the signing of the Treaty of Nijmegen
in 1678, when France was indeed triumphant over these countries.

The cabinet is seemingly supported by the figures of Hercules and the Amazon
Hippolyta, and the military theme is continued in the bronze mounts of military
trophies flanking a portrait medallion of Louis XIV.

A pair to the cabinet belongs to the Duke of Buccleuch and stands in Drumlanrig
Castle, his Scottish country seat. The names of the original owners of these cabinets are
not known.

41 One of Two Coffers on Stands
 French (Paris), circa 1684
 Attributed to André-Charles
 Boulle (1642–1732;
 master before 1666)

Walnut and oak veneered with
tortoiseshell, brass, pewter, horn,
cypress, rosewood, and ebony;
gilt-bronze mounts
Height: 156.6 cm (61⅝ in.)
Width: 89.9 cm (35⅜ in.)
Depth: 55.8 cm (22 in.)
82.DA.109.1–.2

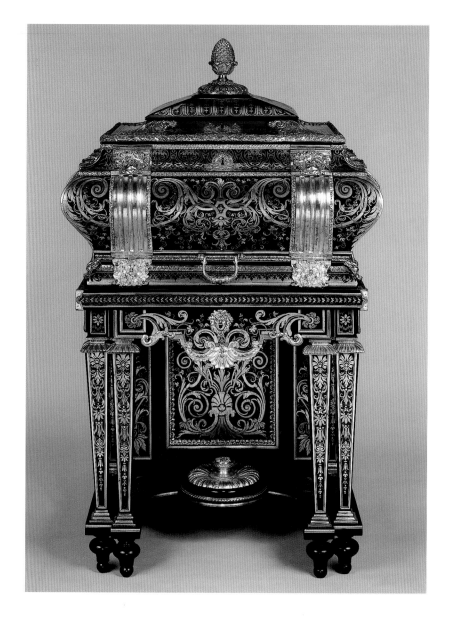

A single coffer of precisely the same model is described in the 1689 inventory of the
Grand Dauphin; according to this inventory, the coffer had been made by Boulle.
The stand is also attributed to this master, but it was added as a support to the coffer
at some point in the late eighteenth or nineteenth century.

 The coffers were probably intended to hold jewels. There are secret compartments
in the base, and small drawers suitable for rings are found beneath the broad gilt-
bronze vertical straps, which, when unlocked, lower on hinges.

 A third coffer, with a ground of pewter, belongs to the Duke of Marlborough at
Blenheim Palace, England.

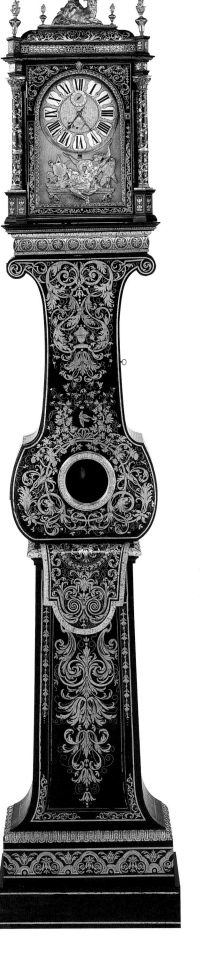

42 Long-Case Clock (*Régulateur*)
French (Paris), circa 1680–1690
The case attributed to André-
Charles Boulle (1642–1732;
master before 1666); the face
inscribed *Gaudron AParis* for
Antoine (I) Gaudron
(circa 1640–1714)

Oak and walnut veneered with
tortoiseshell, brass, pewter, ebony,
and ebonized wood; gilt-bronze
mounts; enameled metal clock
numerals; glass
Height: 246.5 cm (97½ in.)
Width: 48 cm (18½ in.)
Depth: 19 cm (7½ in.)
88.DB.16

This is an early example of the long-pendulum
clock invented in 1657 by Christiaan Huygens.
For protection, the pendulum and the weights
had to be enclosed in a long case; the center
of the narrow case swells to allow for the swing
of the pendulum. The accuracy of this type
of clock, and its ability to demonstrate the
irregularity of the sun's orbit, is alluded to
by the phrase from Virgil's *Georgics* engraved
beneath the dial: *Solem audet dicere falsum*
(It dares the sun to tell a lie).

A clock of the same design, and bearing
marquetry of the same pattern, now in the
Ecole Nationale Supérieure des Beaux-Arts,
Paris, is described in an inventory of the
possessions of Louis XIV. A later inventory
of 1792 identifies the clock as having been
made by André-Charles Boulle.

43 Table
 French (Paris),
 circa 1680
 Attributed to
 André-Charles Boulle
 (1642–1732;
 master before 1666)

Oak veneered with tortoiseshell,
brass, pewter, horn, ebony, ivory,
and marquetry of stained and
natural woods
Height: 72 cm (28⅜ in.)
Width: 110.5 cm (43½ in.)
Depth: 73.6 cm (29 in.)
71.DA.100

Tabletop at right

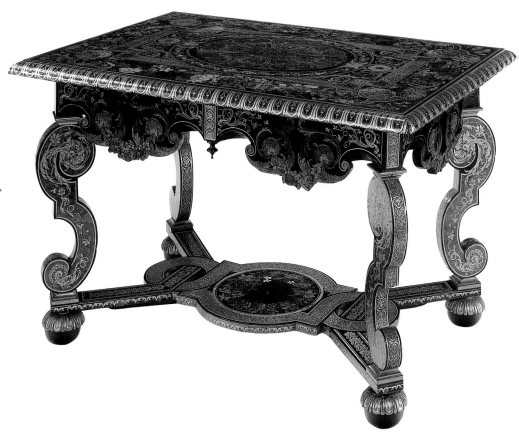

Very few pieces of furniture exist that are veneered with two types of marquetry, in
this case, with wood and with tortoiseshell, brass, and pewter. These pieces all appear
to have been made by the same hand and exhibit many similar motifs. They are always
of the finest craftsmanship and, like this table, were probably made for Louis XIV
or members of his family. Similar tables appear in Louis XIV's inventory, but the
Museum's table has not yet been precisely identified.

 The flowers that enrich the marquetry on the surface of the table (see detail at
right) are all identifiable; among them can be found peonies, hyacinths, daffodils,
tulips, and ranunculus.

44 Tapestry: "Les Astronomes"
 from the series *L'Histoire de
 l'empereur de la Chine*
 French (Beauvais),
 circa 1697–1705
 Woven at the Beauvais
 manufactory under the direction
 of Philippe Béhagle (1641–1705),
 after designs of Guy-Louis
 Vernansal (1648–1729), Jean-
 Baptiste Monnoyer (1636–1715),
 and Jean-Baptiste Belin de
 Fontenay (1653–1715)

Wool and silk; modern cotton lining
Height: 424 cm (167 in.)
Width: 319 cm (125½ in.)
83.DD.338

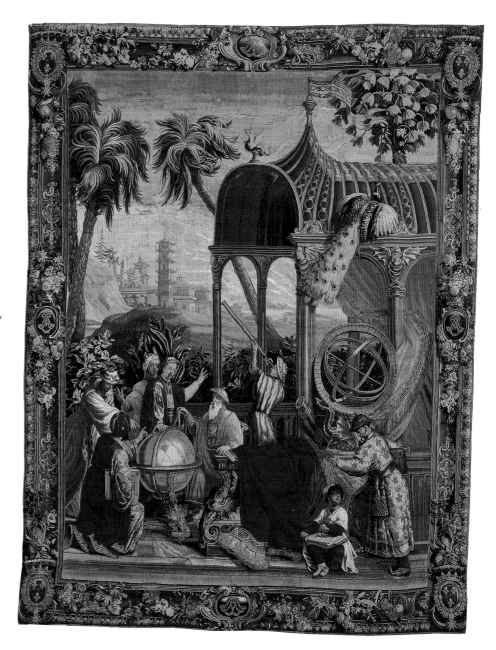

This tapestry is one of a set of ten originally ordered by the comte de Toulouse (1678–1737), the legitimized son of Louis XIV and Madame de Montespan, whose cipher and coat of arms appear in the elaborate borders. The subject portrays a scene from the history of China: the mustached emperor Shunzhi (r. 1644–1661) stands by a globe and confers with the seated, bearded figure of Father Adam Schall von Bell (1592–1666), a German Jesuit priest who gained acceptance at the Qing court through his knowledge of Western astronomy.

The large globe and the armillary sphere on the table are images of actual objects made by the Chinese after European designs. The originals survive today in the observatory of Beijing.

45 Model for a Clock
 French (Paris), circa 1700–1710

Terracotta and enameled metal
clock numerals
Height: 78.7 cm (31 in.)
Width: 52.1 cm (20½ in.)
Depth: 24.2 cm (9½ in.)
72.DB.52

Miniature models for furniture, usually made of wax or terracotta with painted
paper, were sometimes produced for royal commissions, but few have survived.
This full-size model is unique: it is the earliest known Parisian model for a piece
of furniture. It may have been made for Louis XIV by one of the sculptors who
worked for the court, such as François Girardon (1628–1715).

Beneath the dial, Pluto abducts Proserpine in a chariot drawn by four horses.
Although this theme is suitable as a symbol for time and the changing seasons, no
other clock is known with such a representation.

46 Tapestry: "Le Mois de Décembre, le château de Monceaux" from the series *Les Maisons royales*
French (Paris), before 1712
Woven at the Gobelins manufactory in the workshop of Jean de la Croix (*entrepreneur* at the manufactory, 1662–1712), after cartoons painted collaboratively by artists at the Gobelins following designs of Charles Le Brun (1619–1690)

Wool and silk; modern cotton interface and linen lining
Woven in the lower right corner of the border with the signature I.D.L. CROX for Jean de la Croix
Height: 317.5 cm (125 in.)
Width: 330.8 cm (130¼ in.)
85.DD.309

Detail at right

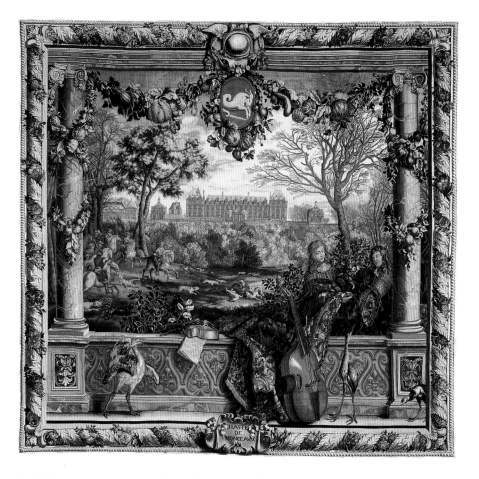

Artistic representations marking the passage of time were rooted in the medieval world of hourly, daily, and seasonal religious devotions. Gradually a secular tradition developed in which sets of tapestries portrayed the zodiacal signs and months of the year through rural or courtly occupations. *Les Maisons royales* was the most original tapestry series of this genre produced at the Gobelins manufactory.

The complete set of twelve hangings showed each astrological sign and month with a royal residence in the background, Louis XIV in the middle ground pursuing one of his daily activities, and a selection of the king's treasures—such as exotic birds, animals, silver, or carpets—in the foreground. This example, probably made for a private patron rather than the crown, represents the month of December and the château of Monceaux (demolished in the eighteenth century), with the king leading a boar hunt.

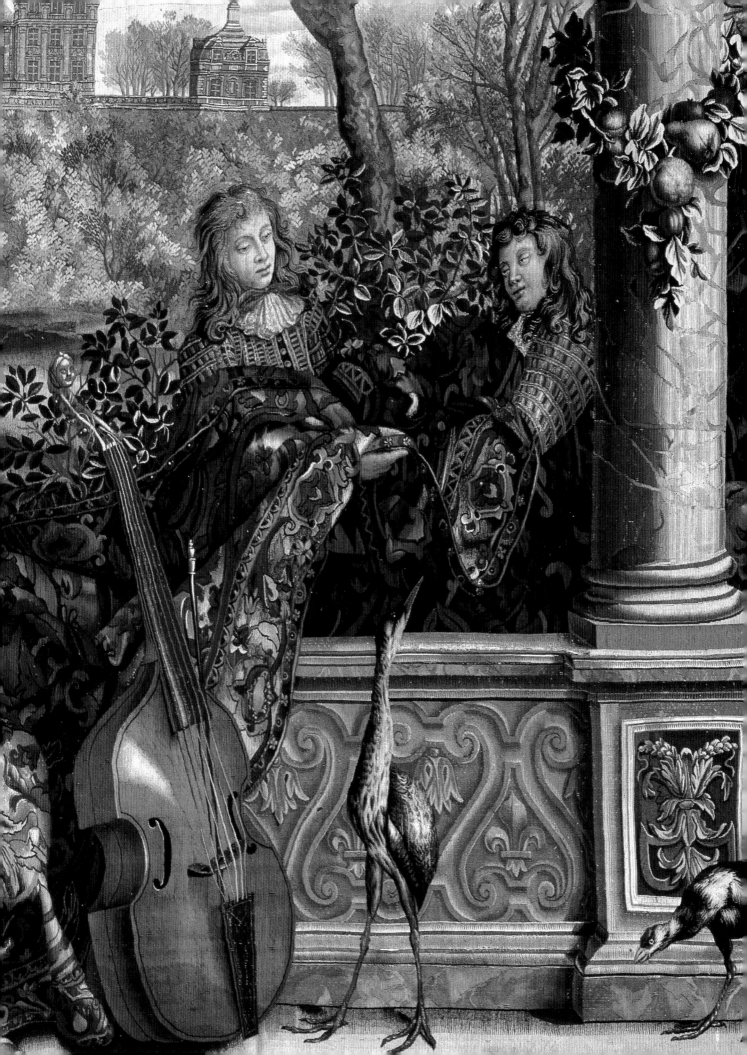

47 Desk (*Bureau Mazarin*)
 French (Paris),
 after 1692–circa 1700

Oak and walnut veneered with brass,
tortoiseshell, pewter, copper, mother-
of-pearl, ebony, painted and unpainted
horn, and painted paper; silvered
and gilt-bronze mounts; steel key.
The top of the desk is set with
unidentified engraved arms (a later
replacement) beneath an electoral
bonnet and surrounded by the Collar
and the Order of the Toison d'Or,
supported by crowned lions.
Height: 70.5 cm (27¾ in.)
Width: 89 cm (35 in.)
Depth: 51 cm (20 in.)
87.DA.77

Detail of desktop at left

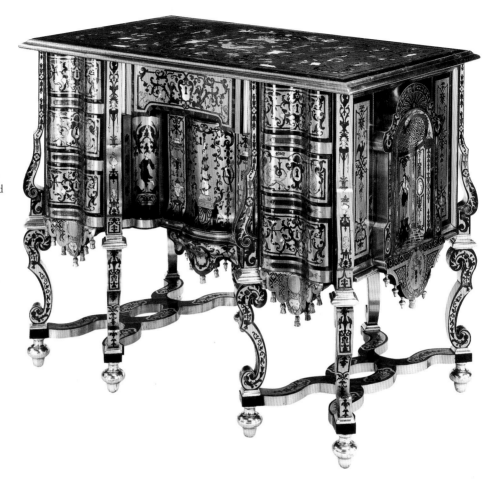

Although the original coat of arms decorating the top of this small desk was replaced
at some date, all the surrounding emblems are those used by the Electors of Bavaria.
The original steel key is pierced with the monogram *ME* beneath an electoral bonnet,
which undoubtedly stands for Max Emanuel (1662–1726). Between 1704 and 1715
the Elector was exiled to France, where he developed a taste for such highly decorated
pieces, many of which are briefly described in his inventories.

The design on the top of the desk (see detail at left) is in the style of the
ornemaniste Jean Berain (1640–1711) and is found on a number of other desks and
tables of this date, but none are equal to the extravagance of this piece, with its use
of many materials of differing colors. Its small size and fragility deny it any practical
purpose; it seems to have been made purely for display.

48 Stool (*Tabouret*)
 French (Paris), circa 1710–1720

Gilded walnut; modern leather
upholstery
Height: 47 cm (18½ in.)
Width: 63.5 cm (25 in.)
Depth: 48 cm (18⅞ in.)
84.DA.970

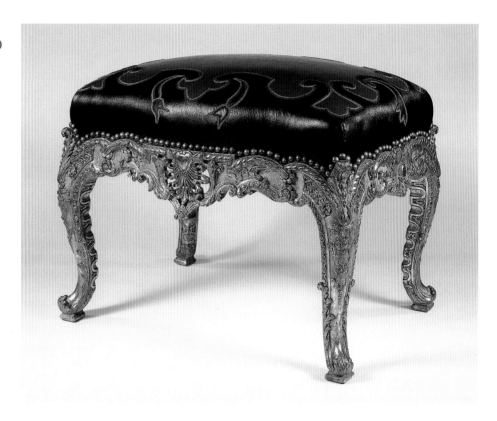

This elaborately carved stool is part of a set of seat furniture consisting of a second
stool, two settees, and six armchairs. They were made for the extremely rich financier
Pierre Crozat (1661–1740), Treasurer of France. The set is described in the inventory
of his house on the rue de Richelieu in Paris, taken at his death in 1740. Two of
the armchairs have recently been given to the Musée du Louvre by one of Crozat's
descendants.

 When acquired by the Museum, the stool had been stripped of its gilding and had
lost its leather upholstery. The gesso and gilding have been replaced, with the existing
chairs used as a model; the appliquéd leather (with its cream and red silk ribbon) was
also copied.

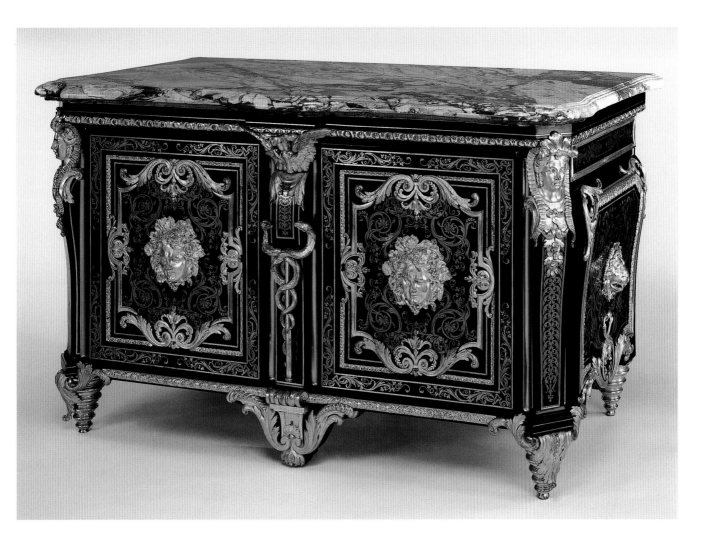

49 Medal Cabinet
 French (Paris), circa 1710–1715
 Attributed to André-Charles
 Boulle (1642–1732;
 master before 1666)

Oak veneered with tortoiseshell, brass,
and ebony; gilt-bronze mounts;
sarrancolin des Pyrénées marble top
Height: 82.5 cm (32½ in.)
Width: 140 cm (55¼ in.)
Depth: 72.5 cm (28½ in.)
84.DA.58

This cabinet originally contained twenty-two shallow drawers intended to hold coins
or medals. The entire interior was removed and the piece converted at some point
into a humidor for cigars. (A pair to the cabinet, in the State Hermitage Museum,
St. Petersburg, still has the original drawers.) Apart from the masks in the center of the
doors and the lions' heads at the sides, all the mounts are unique to this piece. Mercury,
who carried the caduceus, was also the god of commerce, and the use of this symbol on
the front is therefore suitable for a storage place for coins or medals.

The cabinet and its pair are probably those described in an inventory taken in
1767 at the death of Jules-Robert de Cotte, the son of the royal architect Robert de
Cotte. It is likely that Boulle made the cabinets for the latter.

50 One of a Pair of Three-Panel
Screens (*Paravents*)
French (Chaillot),
circa 1714–1740
Made at the Savonnerie
manufactory, after designs by
Jean-Baptiste Belin de Fontenay
(1653–1715) and François
Desportes (1661–1743)

Wool and linen; cotton-twill gimp;
silk velvet; wooden frames
Height: 273.6 cm (107¾ in.)
Width: 193.2 cm (76⅛ in.)
83.DD.260.1–.2

Detail at right

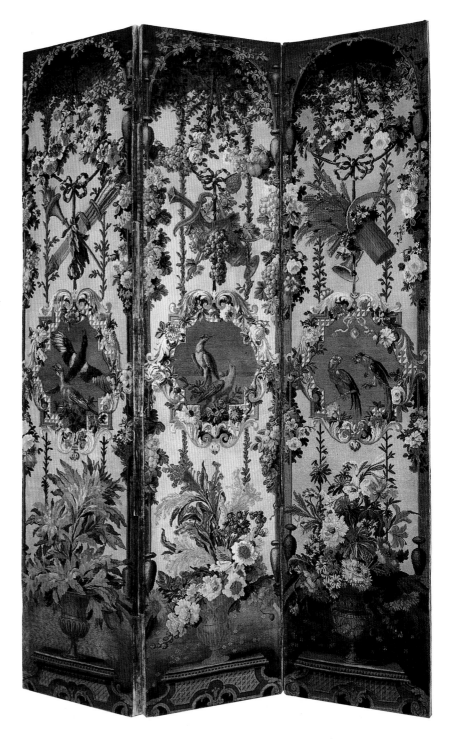

This tall folding screen of three panels is called a *paravent* (literally "against the wind")
and was intended to protect the occupants of an interior from chilly drafts. The
decorative scheme suggests an outdoor arbor on a warm summer day, and this theme
had continuous appeal to owners throughout the eighteenth century. The screen and its
pair were products of the Savonnerie manufactory that produced carpets, bench covers,
and folding screens for the French royal household (see no. 37). The results were highly
durable, and screens such as these suffered little wear over time: this example has
retained much of its original color.

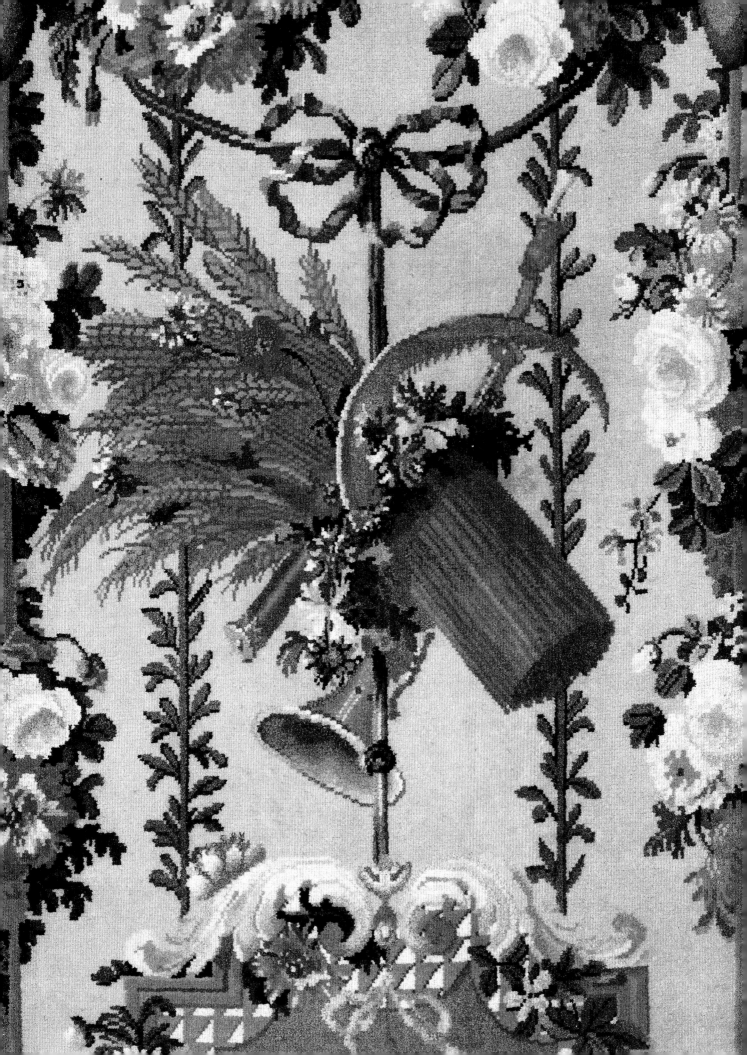

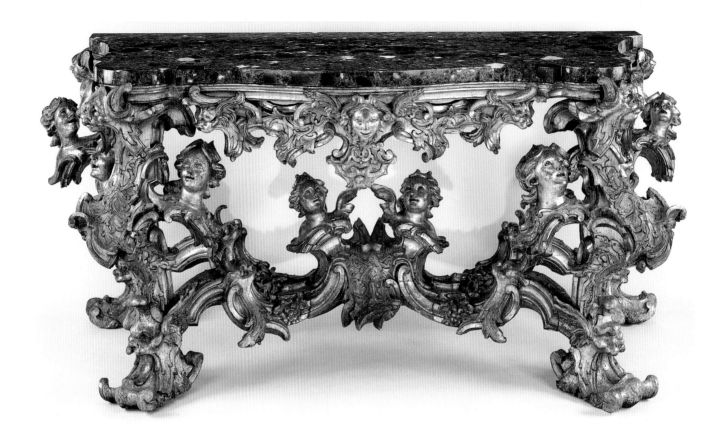

51 Side Table
 Italian (Rome),
 circa 1720–1730

 Carved and gilt linden wood
 and spruce; modern top veneered
 in marble
 Height: 93.9 cm (37 in.)
 Width: 190.5 cm (75 in.)
 Depth: 96.5 cm (38 in.)
 82.DA.8

The form and decoration of this massive table, animated by the masks and female heads turning up and around in many directions, display the dynamic style of the Roman Baroque. Certain aspects of this table, however, point to the transition toward the Rococo, including the bits of draped garlands, the broken and recombined architectural elements, and the freely handled scrolls. Beneath the top, stretchers boldly curve out from the center and connect the four legs, which turn and twist outward.

Companion pieces are located in Grimsthorpe Castle, Lincolnshire, and in the Palazzo Barberini, Rome. Although it is known that the Grimsthorpe piece was acquired in Rome in the summer of 1843, it is not known whether the Barberini table is in its original setting. Still, the three tables were probably part of four or six such tables decorating the grand hall of an important eighteenth-century Roman *palazzo*.

52 Pair of Altar Candlesticks
Italian (Rome),
early eighteenth century

Bronze, partially gilded
Height: 83.3 cm (32¾ in.)
Max. width: 29.8 cm (11¾ in.)
93.DF.20.1–.2

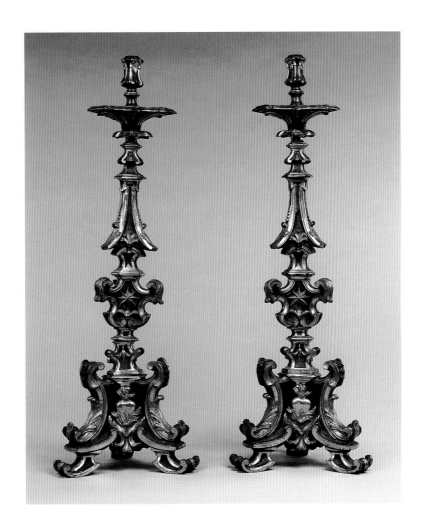

The complex rhythm of curves and countercurves lends a bold and dynamic profile to these elegant candlesticks. The bases and central portions display a flaming heart and eight-pointed stars, both symbols of Saint Filippo Neri (1515–1595), who founded the Congregation of the Oratory, a community of priests without vows, dedicated to prayer and preaching; it was given official status by Pope Gregory XIII in 1575. The flaming heart was a favorite symbol of the saint, whose religious passion was said to move him so strongly that his heart seemed to leap from his chest. Because of these symbols, this pair of candlesticks must have been designed to decorate the altar of a church or chapel dedicated to Saint Filippo Neri.

The style recalls the work of Giovanni Giardini (1646–1722), a Roman bronzecaster, metalworker, and designer who published a book of designs for one hundred candelabra and other objects in 1714. The handling of the flared elements and the fluid profile bring to mind similar undulating treatments of Roman High Baroque facades. The relative downplaying of applied ornament in favor of a simple, strong profile may indicate that the candlesticks were designed by an architect, such as Filippo Juvara (1678–1736), whose brother and father were goldsmiths (see no. 58) and who is known to have designed altar furnishings.

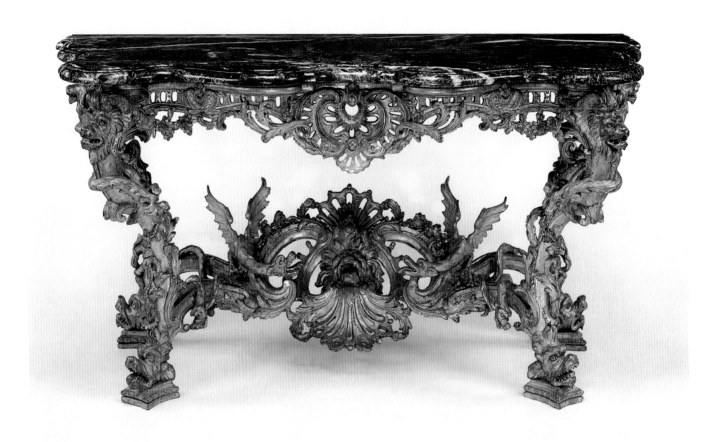

53 Side Table
French (Paris), circa 1730

Gilded oak; *brèche violette* top
Height: 89.3 cm (35 in.)
Width: 170.2 cm (67 in.)
Depth: 81.3 cm (32 in.)
79.DA.68

This side table is an elaborate example of early Rococo carving. The continuous flow of decoration—including carved lions' heads, dragons, serpents, and chimeras—is typical of the fanciful decorative motifs that would dominate the Rococo style.

The table was originally part of a set including two smaller side tables; they would have stood in a large *salon* fitted with paneled walls carved with similar elements. Such interior fixtures that were placed against walls were usually supplied by *menuisiers en bâtiment*. Members of this guild were not required to sign or stamp their work.

54 One of a Pair of Globes
French (Paris)
Terrestrial globe, circa 1728
Globes drawn by the Abbé Jean-
Antoine Nollet (1700–1770);
terrestrial map engraved by
Louis Borde (active 1730s
and 1740s). The lacquered
decoration attributed to the
Martin family (Etienne-Simon,
died 1770; Gilles-François,
died 1795; and Guillaume,
died 1749).

Printed paper; papier-mâché; alder
painted with *vernis Martin;* bronze;
glass
Height: 110 cm (43¼ in.)
Width: 45 cm (17½ in.)
Depth: 32 cm (12½ in.)
86.DH.705.1–.2

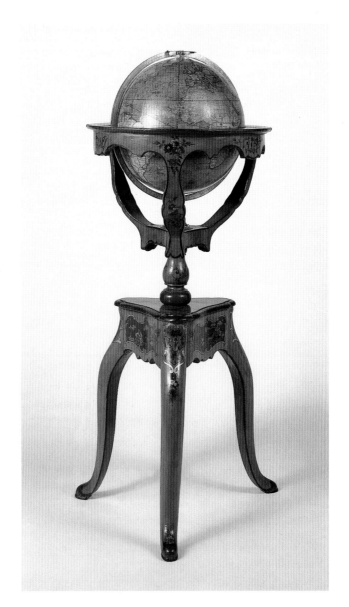

This terrestrial globe, dated 1728, is dedicated by the Abbé Nollet, in a cartouche, to the duchesse du Maine (1676–1743), the wife of Louis XIV's legitimized first son by Madame de Montespan. Nollet was a noted scientist and teacher and was appointed, in 1758, master of physics and natural history to the royal children. The companion celestial globe, dated 1730, is dedicated to the duchess's nephew, the comte de Clermont (1709–1771).

Globes were considered essential adornments for the libraries of the aristocracy, lending an air of scholarly respectability in an age when the mapping of uncharted territories of the world was being undertaken and new trading routes established. Globes frequently appear in eighteenth-century portraits but are usually supported or encased by simple turned columns. These examples, with their red and yellow lacquered stands decorated with oriental scenes, are exceptionally elaborate and may have been made to match similarly lacquered furniture.

55 Commode
French (Paris), circa 1735–1740
Attributed to Charles Cressent
(1685–1768)

Pine and walnut veneered with *bois satiné* and amaranth; gilt-bronze mounts; *brèche d'Alep* top
Height: 90.2 cm (35½ in.)
Width: 136.5 cm (53¾ in.)
Depth: 64.8 cm (25½ in.)
70.DA.82

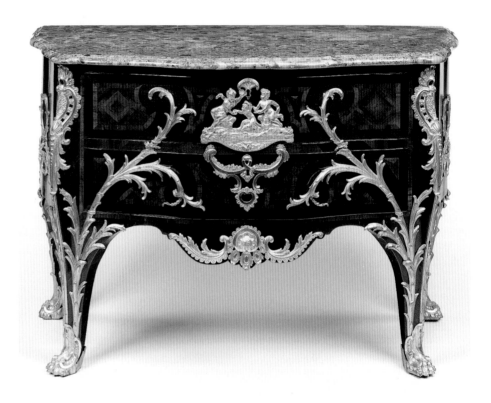

Charles Cressent, having been trained as a sculptor in the Académie de Saint-Luc, was well able to design his own gilt-bronze mounts. These he had made in his workshop, which was a contravention of the strict guild rules of the time; the craft of casting and gilding bronze was reserved for a separate guild. On a number of occasions Cressent was fined for these infringements, and in order to raise money to pay the penalties he was forced to hold sales of his stock. The sale catalogues, which he wrote, still exist. In the catalogue for a sale in 1756, we find the following entry: "No. 132 Une commode de quatre pieds, marbre Brèche violete, les bronzes représentent deux enfans qui râpent du tabac, au milieu est un singe qui se poudre de tabac, dorés d'or moulu" (No. 132: A commode four feet high, marble of *brèche violette*, the bronzes representing two children who are stealing snuff; in the middle is a monkey powdering itself with snuff; [made of] gilt bronze).

That the commode was still in Cressent's possession some twenty years after its construction indicates that it did not sell well. Indeed, Cressent made no other commode exactly like it, whereas a number of his other commodes duplicate one another.

56 Wall Clock (*Pendule d'Alcove*)
French (Paris and Chantilly),
circa 1740
Movement by Charles Voisin
(1685–1761; master 1710);
case made at the Chantilly
porcelain manufactory

Soft-paste porcelain, polychrome
enamel decoration; gilt-bronze
mounts; enameled metal clock dial;
glass clock door
Height: 74.9 cm (29½ in.)
Width: 35.6 cm (14 in.)
Depth: 11.1 cm (4⅜ in.)
81.DB.81

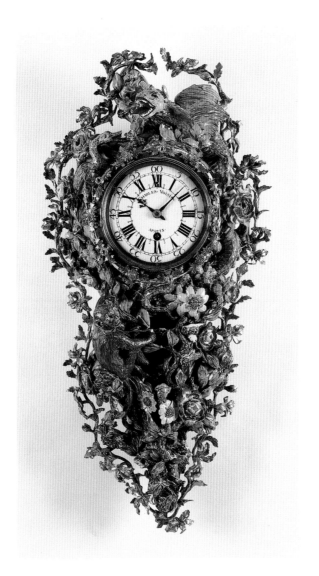

The case of this clock was made of soft-paste porcelain at the Chantilly manufactory,
which was established in 1725 by the prince de Condé. Initially the design of products
made at the manufactory was influenced by the extensive collection of Japanese
ceramics assembled by its founder. By the 1740s, however, this influence had given
way to a whimsical European interpretation of exotic motifs. The color of the glazes is
typical of this manufactory.

Clock movements designed for the alcoves of bedchambers (*pendules d'alcove*) were
fitted with a repeating mechanism that chimed the nearest hour and quarter hour when
activated by pulling on a string, obviating the need to light a candle to see the dial.

57 One from a Set of Four
 Armchairs
 Italian (Venice),
 circa 1730–1740

Carved and gilt walnut and pine
upholstered in modern Genoese velvet
Height: 140 cm (55⅛ in.)
Width: 86 cm (33⅞ in.)
Depth: 87 cm (34¼ in.)
87.DA.2.1

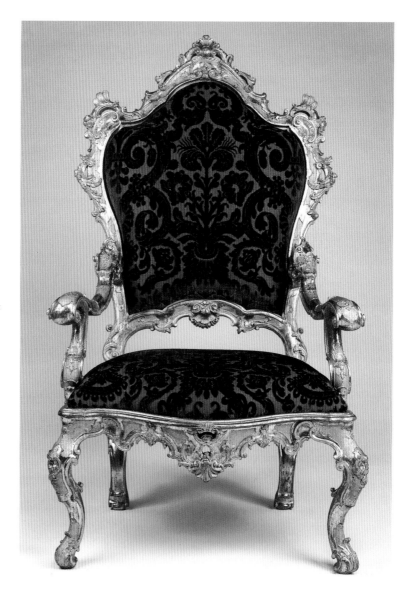

Although its maker is unknown, this armchair shows strong stylistic similarities
to furniture attributed to Antonio Corradini (circa 1700–1752), continuing in the
manner of the great furniture carver Andrea Brustolon. A major innovator of the time,
Corradini is best known as the sculptor who was commissioned in the early eighteenth
century by the city of Venice to decorate the last *Bucintoro*, or Venetian state barge.
Fragments of this ceremonial ship, now preserved in Venice's Museo Correr, have
prompted scholars to attribute to this artist a number of side chairs, consoles, tables,
and a throne in the Ca' Rezzonico, Venice. The Museum's armchairs share with the Ca'
Rezzonico pieces elegant proportions and lavish carving in the round that incorporates
fully sculptural ornamentation with curvilinear scrolls, garlands, and foliate motifs.

With their combination of exuberant and delicate forms, these chairs are
characteristic of the mid-eighteenth-century transition from a heavier, Baroque
furniture style toward the more gracefully voluptuous forms of the European Rococo.
Their high-quality carving and gilding suggest that these opulent chairs probably
functioned as much for decoration as for seating.

58 Wall Plaque
 Italian (Sicily), circa 1730–1740
 By Francesco Natale Juvara
 (1673–1759)

 Silver, gilt bronze, and lapis lazuli
 Height: 70 cm (27⁹⁄₁₆ in.)
 Width: 52 cm (20½ in.)
 85.SE.127

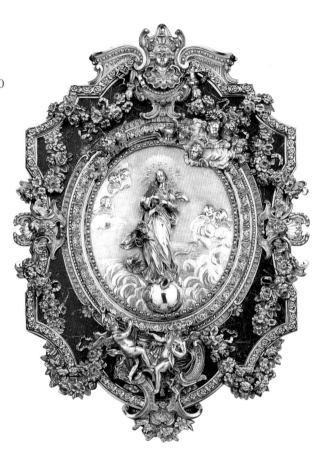

Son of the goldsmith Pietro and brother of the architect Filippo (see no. 52), Francesco
Juvara established a significant reputation as a maker of fine liturgical metalwork. His
wall plaques, altar frontals, monstrances, and chalices once graced the interiors of
many Roman as well as Sicilian churches. This plaque represents the Virgin of the
Immaculate Conception, surrounded by cherub heads and crowned Queen of Heaven
as she tramples a snake, symbol of sin. The highly reflective surfaces of the globe and
Mary's body are set against the dull striated surfaces of the clouds and background,
which have been stamped repeatedly by a small tool. Through this subtle contrast
of textures, Juvara ensured that the central relief medallion would have the same
decorative impact as its more ornate and colorful frame.

Juvara executed another relief plaque of the same dimensions, similarly framed in
lapis and precious metal, which depicts the Madonna and Child with Saint John in a
landscape setting. It is last recorded as belonging to the Prince of Piedmont in Naples.
The two silver plaques glorifying Mary as mother of Christ were probably made as a
pair, or part of a series, for the decoration of a private chapel or church.

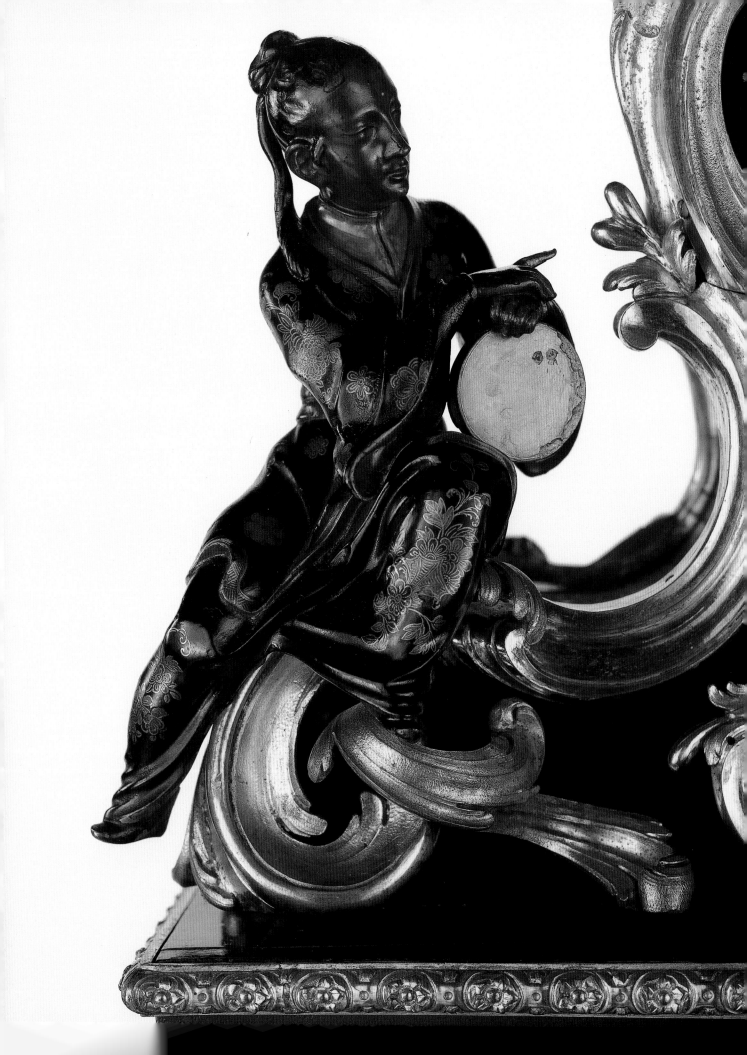

59 *Cartonnier* with
 Bout de Bureau and Clock
 French (Paris); *cartonnier* and
 bout de bureau, circa 1740;
 clock, 1746
 Cartonnier and *bout de bureau*
 stamped BVRB for Bernard (II)
 van Risenburgh (after 1696–
 circa 1766; master before 1730).
 Clock dial and movement signed
 Etienne Le Noir AParis for
 Etienne (II) Le Noir (1699 –
 1778; master 1717). Back of
 the dial bears the inscription
 .decla.1746 for the enameler
 Jacques Decla (active by 1742–
 died after 1764). The name of
 the maker of the clock case is
 not known.

 Oak veneered with ebonized alder and
 painted with *vernis Martin;* gilt-bronze
 mounts; painted bronze figures;
 enameled and painted metal clock
 dial; glass clock door
 Height: 192 cm (75⅜ in.)
 Width: 103 cm (40⁹⁄₁₆ in.)
 Depth: 41 cm (16⅛ in.)
 83.DA.280

 Detail at left

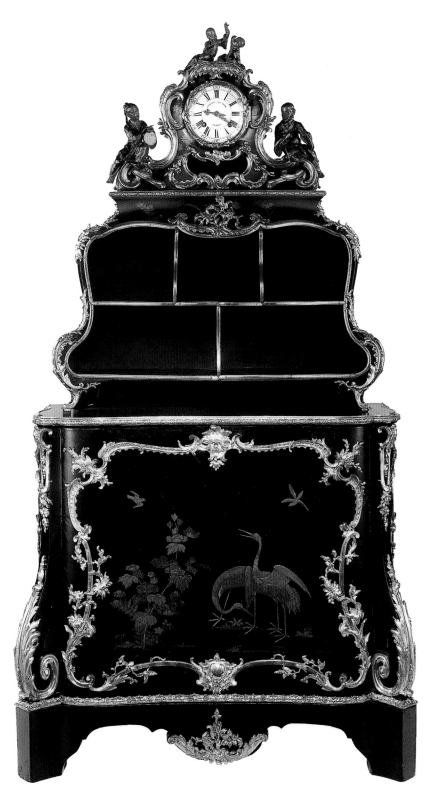

This piece of furniture was meant to be used like a modern filing cabinet. Papers were placed in leather-fronted cardboard boxes that were fitted into the open shelves. A writing table (*bureau plat*), decorated in the same manner, would have been placed in front of it.

 The black and gold decoration is of *vernis Martin,* a French imitation of oriental lacquer named after the Martin brothers who excelled in the craft. The Chinese figures (see detail at left) were also probably supplied by the Martin brothers.

60 Wall Clock (*Pendule à Répétition*)
French (Paris), circa 1735–1740
Movement engraved *Fieffé AParis*
for the clockmaker Jean-Jacques
Fieffé (circa 1700–1770; master
1725). Dial painted FIEFFE
DELOBSERVATOIR. The name
of the maker of the case is
not known.

Gilt bronze; enameled metal clock dial;
glass clock door; oak back board
Height: 133.4 cm (52½ in.)
Width: 67.3 cm (26½ in.)
Depth: 14.4 cm (5⅝ in.)
72.DB.89

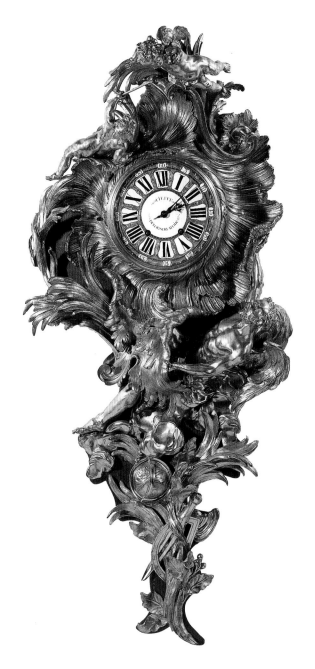

The figures on this clock represent Love conquering Time, a theme often repeated
on French clocks of this period. The two cherubs above carry away the scythe and
hourglass of Time, while he lies vanquished below with his globe, protractor, and pair
of compasses. Such clocks, also known as *pendules d'alcove* (see no. 56), were usually
of small size, suitable for a bed alcove. This is perhaps the largest example known,
indicating that it was made for an extremely grand interior.

 The fully Rococo design of this clock, with its swirling forms and total asymmetry,
may be attributed to the *ornemaniste* Juste-Aurèle Meissonnier (1695–1750).

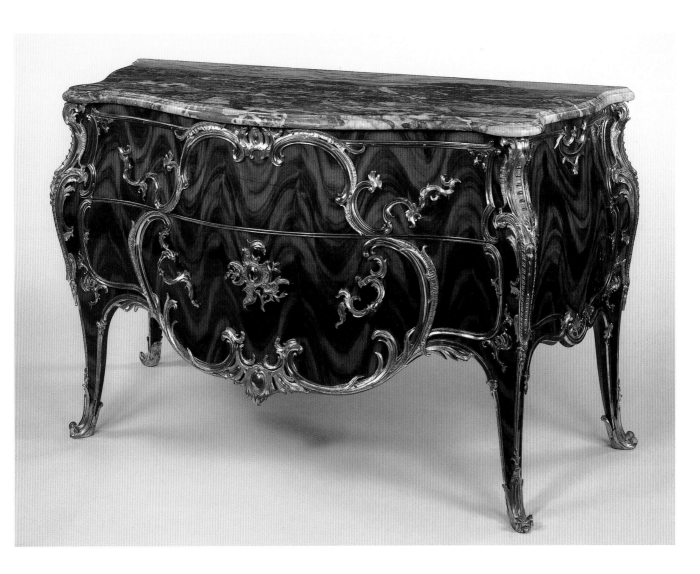

61 Commode
French (Paris), circa 1745–1749
Attributed to Jean-Pierre Latz
(circa 1691–1754)

Oak veneered with *bois satiné;*
gilt-bronze mounts; *fleur de pêcher*
marble top. One mount stamped
with the crowned C for 1745–1749.
Height: 87.7 cm (34½ in.)
Width: 151.5 cm (59⅝ in.)
Depth: 65 cm (26⅝ in.)
83.DA.356

Although this commode is not stamped with a cabinetmaker's name, it can be firmly attributed to Latz because his stamp is found on a commode of precisely the same design now in the Palazzo del Quirinale, Rome. That commode was taken to Italy in 1753 by Louise-Elisabeth, a daughter of Louis XV, who had married Philip, Duke of Parma, son of Philip V of Spain.

Latz was primarily a marquetry craftsman, and the technical quality of his marquetry was consistently high. The strongly grained veneer forming a wave pattern is an unusual form of decoration found on only a few pieces of French furniture of the mid-eighteenth century. It is a very complex pattern of marquetry: the veneers are cut at an angle through a piece of wood to produce ovals and then carefully matched so that the graining creates waving lines.

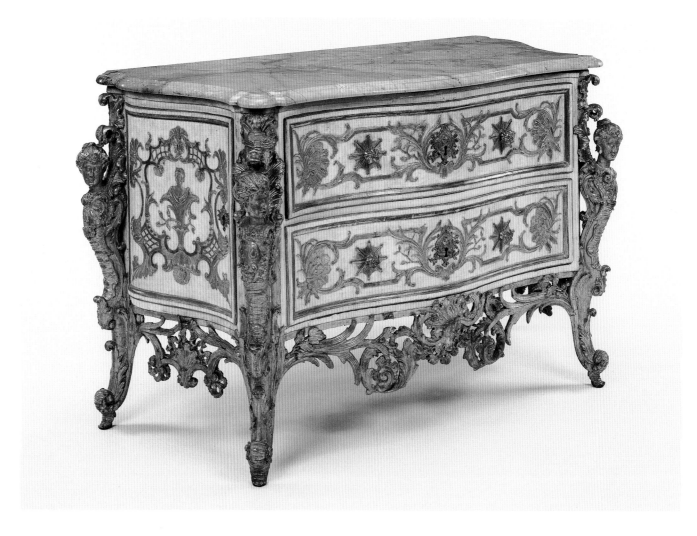

62 One of a Pair of Commodes
German (Munich), circa 1745
Carving attributed to Joachim
Dietrich (died 1753); side
panels after engraved designs
by François de Cuvilliés
(circa 1695–1768)

Pine gessoed, painted, and gilded;
gilt-bronze mounts; *jaune rosé de
Brignolles* marble top
Height: 83.2 cm (32¾ in.)
Width: 126.4 cm (49¾ in.)
Depth: 61.9 cm (24⅜ in.)
72.DA.63.1–.2

This ornately carved German commode and its companion piece were influenced
by the engravings of François de Cuvilliés, one of the leading interpreters of the
Rococo style and an architect for Max Emanuel (1662–1726), Elector of Bavaria.
The combination of white painted planar surfaces and the gilded, pierced elements
probably reflects the interior for which it was originally designed. The commode
offers a contrast to the contemporary French style, which would have applied gilt-
bronze mounts where the German maker has used carved and sculpted wood.

63 One of a Pair of Cabinets
French (Paris), circa 1745–1750
Stamped BVRB for Bernard (II)
van Risenburgh (after 1696–
circa 1766; master before 1730)

Oak veneered with *bois satiné*,
amaranth, and cherry; gilt-bronze
mounts
Height: 149 cm (58⅝ in.)
Width: 101 cm (39¾ in.)
Depth: 48.3 cm (19 in.)
84.DA.24.1–.2

This low cabinet and its companion piece are of unique form and were probably intended to hold small *objets d'art* (such as porcelains and bronzes) or natural objects of curiosity (such as shells, corals, and minerals). A shelf, situated beneath the upper doors, can be pulled out and may have been used by the owner while rearranging and studying his or her collection. Many wealthy Europeans maintained such collections, and their avid study was a constant preoccupation during the Enlightenment.

The wire-mesh screens in the upper doors are modern replacements. Such screens were commonly used in place of glass on objects of this type in the eighteenth century.

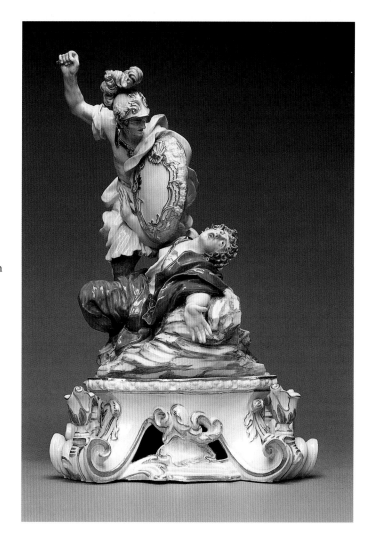

64 One of a Pair of Porcelain
 Groups: *Perseus and Medusa*
 Italian (Florence), circa 1749
 Produced in the Doccia porcelain
 factory; based on models by
 Giovanni Battista Foggini
 (1652–1725); finished by
 Gaspero Bruschi (1701–1725);
 painted in the workshop of
 Johann Karl Wendelin Anreiter
 von Zirnfeld (active at Doccia,
 1739–1745)

 Porcelain, polychromed and
 partially gilt
 Height: 35 cm (13¾ in.)
 Width: 29 cm (11⁷⁄₁₆ in.)
 Depth: 20.1 cm (8¼ in.)
 94.SE.76.2

 Detail at right

The subject of this figure group derives from an episode in Ovid's *Metamorphoses* in
which the hero surprised Medusa in her sleep and, avoiding her deadly gaze by looking
at her reflection in his polished shield, decapitated her with his curved sword. The
small urns at the four corners indicate that this sculpture served as a candelabrum
and would have been a particularly theatrical addition to its dining-table setting.

 The composition of this group was first created as a model for a bronze by
Giovanni Battista Foggini, the preeminent sculptor active in early-eighteenth-century
Florence. After the artist's death in 1725, the piece-molds of most of Foggini's bronzes
passed to his son, Vincenzo, also a sculptor. Vincenzo then passed a number of these
models on to Doccia for the production of many of the factory's early figures and
figure groups.

 The technique and style of the delicate, almost jewel-like polychrome enamel
painting point to the Viennese gilder and porcelain painter Anreiter von Zirnfeld,
who had worked at the Vienna porcelain factory of C. I. Du Paquier until 1737,
when Carlo Ginori engaged him as chief painter for the Doccia factory.

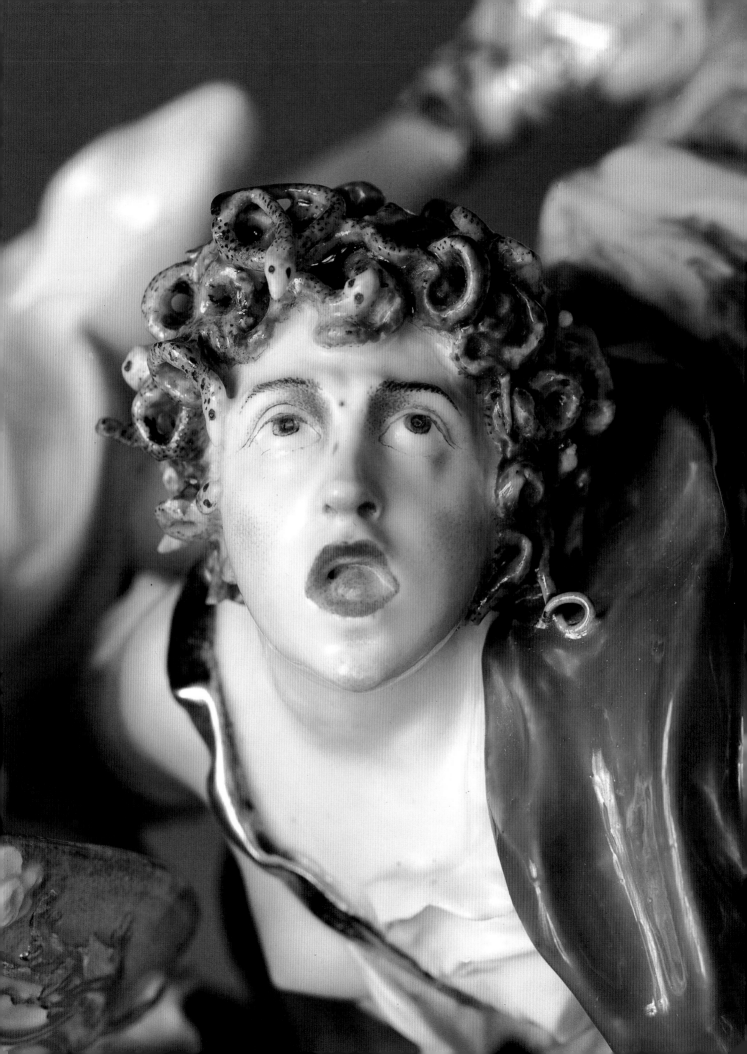

65 Microscope and Case
 French (Paris), after 1749
 Micrometric stage invented by
 Michel-Ferdinand d'Albert
 d'Ailly, fifth duc de Chaulnes
 (1714–1769); gilt-bronze mount
 attributed to Jacques Caffieri
 (1678–1755)

Gilt bronze; enamel; shagreen; glass
and mirror glass; case of tooled and
gilded leather; brass; velvet; silver lace
and braid; slides of various natural
specimens and brass implements
(Microscope)
Height: 48 cm (18⅞ in.)
Width: 28 cm (11 in.)
Depth: 20.5 cm (8¹⁄₁₆ in.)
(Case)
Height: 66 cm (26 in.)
Width 34.9 cm (13¾ in.)
Depth: 27 cm (10⅝ in.)
86.DH.694

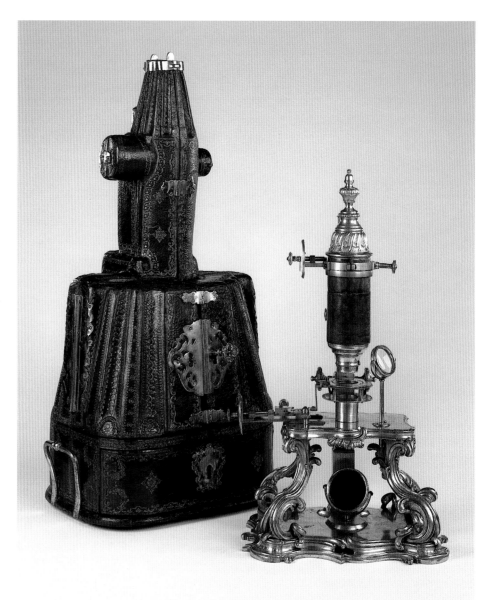

This microscope demonstrates the close affinity of the arts and sciences in France
during the eighteenth century. While the gilt-bronze stand followed the prevailing
taste in fashion, the instrument incorporated the latest technological invention—
the micrometric stage—that significantly improved the quality and caliber of its
magnifying capabilities.

 As with so many of the instruments designed for the circle of noble dilettante
scientists associated with both the court and the Academy of Sciences, this microscope
and its original tooled leather case reflect the consummate skill of such artisans as
the *bronzier* who made the stand and the *relieur* (binder) who provided the case. A
microscope of this same model belonged to Louis XV and was part of his *observatoire*
at the château of La Muette.

66 Tabletop
Italian (Castelli), circa 1760
By Francesco Saverio II Maria
Grue (Naples, active in Castelli;
1731–1799)

Tin-glazed earthenware
Height: 3.2 cm (1¼ in.)
Diameter: 59.7 cm (23½ in.)
86.DE.533

This unusual object is the only known Italian eighteenth-century tabletop made of maiolica. The Rococo style of painting in a predominantly green and yellowish-green palette is typical of objects produced in the Grue workshop, long connected with the manufacture of painted maiolica at Castelli in the Abruzzi region. Saverio, the last member of this renowned family, specialized in landscape and genre scenes in a loose, almost sketchy painting style. The decorative cartouches and intertwined vegetal motifs on this tabletop exemplify the eighteenth-century emphasis on freely handled naturalistic motifs and fanciful curvilinear forms. The charming and delicate pastoral scenes, as well as the depictions of exotic subject matter such as Moors hunting elephants and ostriches, are also typical of the Rococo taste at midcentury. The four hunting scenes framed by elaborate cartouches, two of which bear the monogram of the artist, copy engravings by Antonio Tempesta (1555–1630). The inscriptions in Latin on the two shields in the foreground read "Blond Ceres, whose hair is enwreathed in grain" and "Each man is the maker of his own fortune."

67 One of a Pair of Lidded Tureens,
Liners, and Stands
French (Paris), 1744–1750
By Thomas Germain
(1673–1748; master 1720;
orfèvre du Roi 1723–1748)

Silver
Originally engraved with an
archbishop's coat of arms and flanking
tassels and surrounded by the collar
and cross of the Order of Christ, now
partially erased and replaced with the
arms of a later owner, Robert John
Smith, 2nd Lord Carrington
(Tureen)
Height: 30 cm (11³⁄₁₆ in.)
Width: 34.9 cm (13¾ in.)
Depth: 28.2 cm (11⅛ in.)
(Stand)
Height: 4.2 cm (1⅝ in.)
Width: 46.2 cm (18³⁄₁₆ in.)
Depth: 47.2 cm (18⁹⁄₁₆ in.)
82.DG.13.1–.2

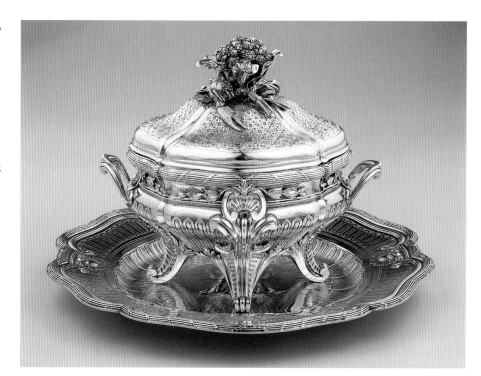

This large lidded tureen with stand is one of a pair that probably comprised only
part of a sumptuous silver table service. Although altered, the engraved coat of arms
on the stand still retains the heraldic symbols of a Portuguese archbishop, possibly
the archbishop of Braga, Dom Gaspar de Bragança (1716–1789). During the mid-
eighteenth century, wealthy members of the Church hierarchy and European courts
patronized Thomas Germain and his son François-Thomas Germain, the famous
French silversmiths who were considered the finest craftsmen in their profession.

The vegetables and small shellfish that form the finial of the lid were cast in part
from nature. The realism of such details appealed to patrons, many of whom were
amateur scientists and collectors of natural curiosities.

68 One of a Set of Four Wall Lights
French (Paris), 1756
By François-Thomas Germain
(1726–1791; *orfèvre du Roi*
1748–1764)

Gilt bronze
Engraved FAIT PAR F.T.GERMAIN.
SCULP.ORF.DU ROI AUX
GALERIES DU LOUVRE.1756
Height: 99.6 cm (39¼ in.)
Width: 63.2 cm (24⅞ in.)
Depth: 41 cm (16⅛ in.)
81.DF.96.1–.4

This wall light is one of eight made in 1756 by François-Thomas Germain for the
duc d'Orléans's residence of the Palais Royal in Paris. Modeled in the form of laurel
branches tied together with a ribbon, they may have been designed by the architect
Pierre Contant d'Ivry, who was redecorating the palace's interiors at this date. They
are shown in situ in two engravings published in Diderot and d'Alembert's *Encyclopédie*
in 1762.

While the lights are massive in scale, their detailed chasing and burnishing reveal
the skill of their maker, who was silversmith to the king. Each wall light varies slightly,
and no one model repeats another.

Later in the eighteenth century the wall lights were acquired by the crown and
hung in Marie Antoinette's apartments in the château of Compiègne.

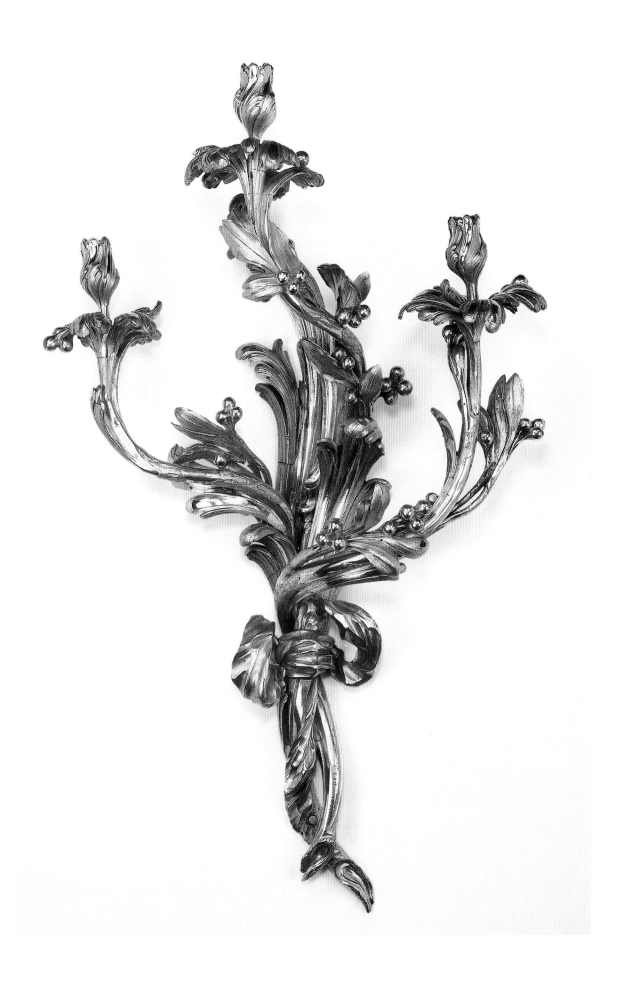

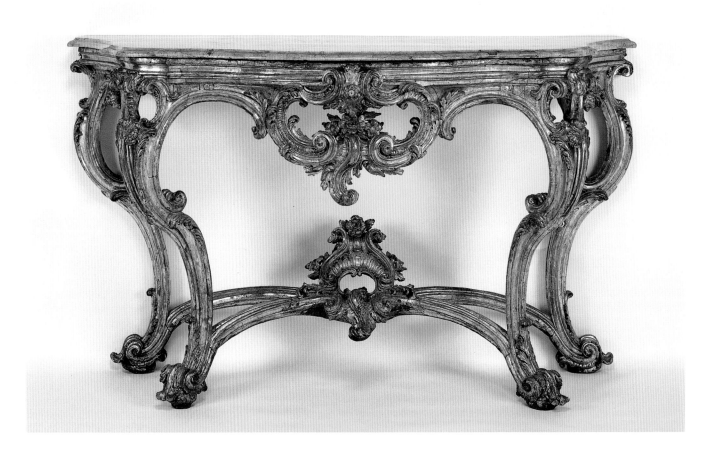

69 Side Table
 Italian (Sicily),
 mid-eighteenth century

 Silver-gilt limewood with a
 limestone top
 Height: 104 cm (41 in.)
 Width: 183 cm (72 in.)
 Depth: 78 cm (30¾ in.)
 95.DA.6

This remarkable table displays a rather eccentric elaboration of Rococo elements, including the large "skirted" feet, pierced rail cartouche, bifurcated legs, and curved stretchers that, because of their ribbed decoration, appear to be made of pulled taffy rather than carved wood. The counterplay between the swollen upper-leg curves and the "taut" lower stretchers, together with the asymmetrical Rococo decoration, gives this table an unusually spirited form. Indeed, this strong emphasis on structure, which is animated but not subsumed by the decorative elements, is a quintessentially Italian feature.

This silver-gilt table would have originally been covered with a yellowish varnish to imitate gold. In fact, actual gold was used very rarely on furniture from the south of Italy because of the high price of gold or difficulty in obtaining the precious metal. As a result, most southern Italian gilded furniture was decorated with just this sort of "poor man's" gilding called *argento meccato*. To create this effect, a piece of furniture was painted with a rich bole ground on which the silver was applied; the silver surface was then covered with a warm-colored varnish, called the *mecca*, creating a characteristic goldlike luster.

70 *Saint Joseph and the Infant Christ*
Italian (Naples), 1790s
Attributed to Gennaro Laudato (known active in the 1790s), after a model by Giuseppe Sanmartino (1720–1793)

Polychrome *terraglia* (white-bodied glazed earthenware)
Height: 54.3 cm (21⅜ in.)
91.SE.74

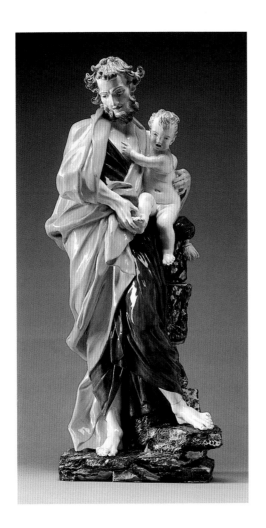

The subject and composition of this work are identical to those of a life-size marble of 1790/91 by the Neapolitan sculptor Giuseppe Sanmartino in the San Cataldo Chapel of the Taranto Cathedral. Sanmartino produced a number of terracotta models for his large-scale sculptures, and it is likely that this ceramic figure group copies one of his *modelli*. Little is known of Gennaro Laudato except that he appears to have been active in Naples in the 1790s and that he may have been a student of Sanmartino's. He has been identified thanks to the fact that he signed several of his creamware figures and figure groups, including a Madonna and Child in the British Museum, London; a Tobias and the Angel in a Neapolitan private collection; and the body of a crucified Christ in the Museo di Capodimonte, Naples.

The modeling and painting of this work combine a sensitive treatment of the facial expressions, a theatrical yet elegant rendering of gesture and pose, dynamic swirling drapery and hair, and brilliant, gemlike colors.

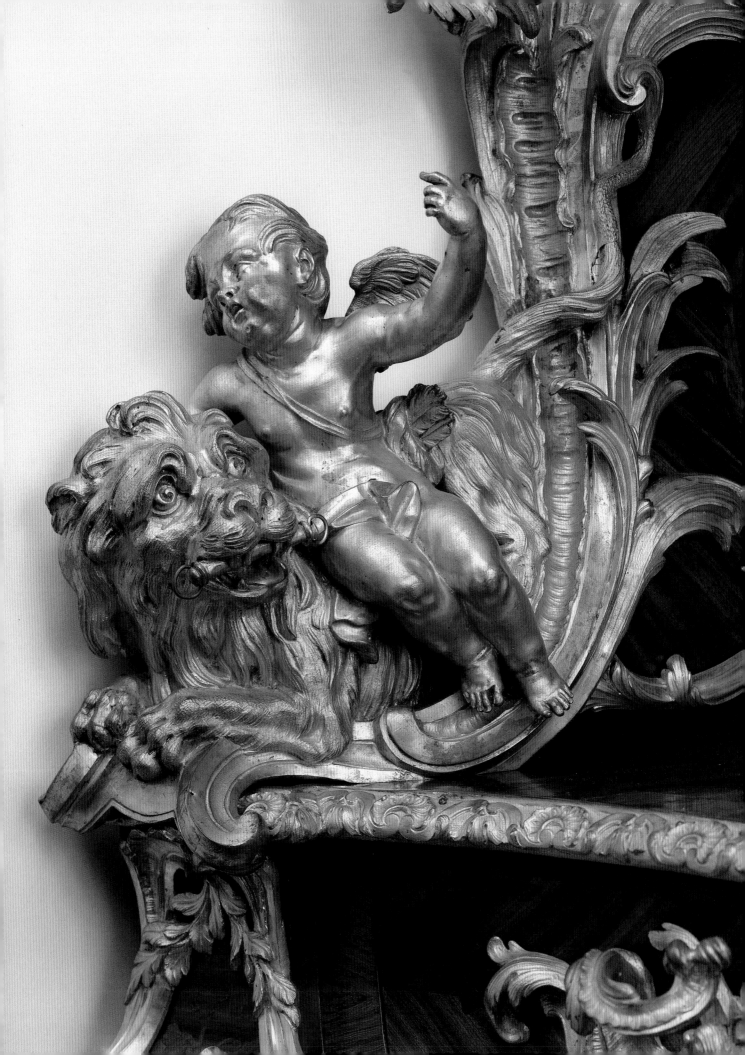

71 Corner Cabinet
 French (Paris), cupboard:
 1744–1753; clock: 1744
 Stamped I.DUBOIS for Jacques
 Dubois (1694–1763; master
 1742), after a drawing by
 Nicolas Pineau (1684–1754);
 clock movement by Etienne (II)
 Le Noir (1699–1778; master
 1717); enamel dial by Antoine-
 Nicolas Martinière (1706–1784;
 master 1720)

Oak, mahogany, and spruce veneered
with *bois satiné* and kingwood;
enameled metal clock dial; gilt-bronze
mounts; glass clock door
Height: 289.5 cm (114 in.)
Width: 129.5 cm (51 in.)
Depth: 72 cm (28½ in.)
79.DA.66

Detail at left

This monumental corner cabinet follows a drawing (later engraved) by the French architect and *ornemaniste* Nicolas Pineau (1684–1754), an early proponent of the Rococo style. But its scale and exuberance do not reflect Parisian taste. The cabinet was actually commissioned by a Polish general, Count Jan Klemens Branicki (1689–1772), who placed the order through the Warsaw dealer (*marchand-mercier*) Lullier. The Paris workshop of Jacques Dubois produced the cabinet between 1744 (the date enameled on the reverse of the clock dial) and sometime around 1753. Once it was delivered to Branicki's palace in Warsaw, it stood as a pendant to a large tiled stove in the main formal room (*chambre de parade*).

72 Desk
 French (Paris), circa 1750
 Stamped BVRB for Bernard (II)
 van Risenburgh (after 1696–
 circa 1766; master before 1730)

 Oak and mahogany veneered with
 tulipwood, kingwood, and *bois satiné;*
 gilt-bronze mounts
 Height: 107.8 cm (42½ in.)
 Width: 158.7 cm (62½ in.)
 Depth: 84.7 cm (33⅜ in.)
 70.DA.87

The marquetry of this desk is characteristic of the cabinetmaker Bernard (II) van
Risenburgh, known as BVRB from the initials of his stamp. He often veneered
furniture with patterns of leafy silhouettes and vines that seemed to sprout from
the sculptural gilt-bronze mounts.

 The double form of this desk is unique. Writing surfaces on both sides can
be lowered to reveal drawers and pigeonholes. BVRB created numerous pieces of
furniture, most of individual and inventive design. He worked almost exclusively for
dealers who continually commissioned pieces of new form and unusual materials in
their efforts to create new (and expensive) tastes among their fashion-loving clientele.

73 Commode
 French (Paris), circa 1750
 Attributed to Joseph Baumhauer
 (died 1772; *ébéniste privilégié du
 Roi* circa 1749)

Oak veneered with ebony; set with
panels of Japanese lacquer, painted
with *vernis Martin;* gilt-bronze mounts;
campan mélangé vert marble top
Height: 88.3 cm (34¾ in.)
Width: 146.1 cm (57½ in.)
Depth: 62.6 cm (24⅝ in.)
55.DA.2

This commode exemplifies the European passion for objects from the Far East and the
Parisian taste for transforming these foreign wares into quintessentially French objects.
While its form is strictly French, this chest of drawers is decorated in the *chinoiserie*
style. It bears three panels of Japanese lacquer removed from an imported chest, their
seams hidden under the finely chased and heavily gilded mounts. The remainder of
the surface was painted in Paris with *vernis Martin,* an imitation of oriental lacquer.

 Although this commode was not stamped by a cabinetmaker, it does have two
duplicate trade labels for the dealer Charles Darnault, who sold it and other luxury
goods in his Parisian shop, *Au Roy d'Espagne.*

74 Reading and Writing Stand
 German (Neuwied-am-Rhein),
 circa 1760–1765
 By Abraham Roentgen
 (1711–1793)

Pine, oak, and walnut veneered with
palisander, alder, rosewood, ebony,
ivory, and mother-of-pearl; gilded
metal fittings. The tabletop bears,
in ivory, the archiepiscopal coat of
arms and monogram *JPC* for Johann
Philipp Churfurst von Walderdorff
(1701–1768), Prince Archbishop
and Elector of Trier.
Height: 76.8 cm (30½ in.)
Width: 71.7 cm (28½ in.)
Depth: 49.8 cm (19¼ in.)
85.DA.216

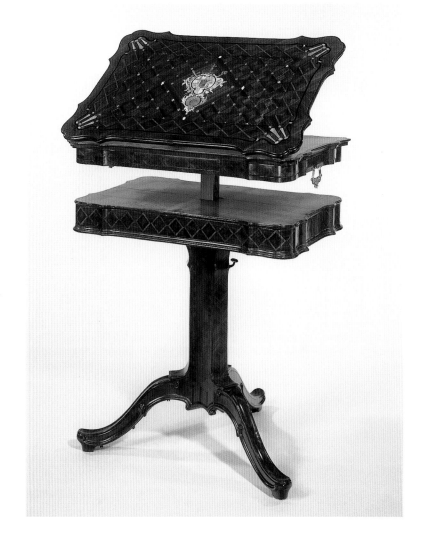

When closed, this stand appears to be of a simple table form, yet it extends and opens
in a complex manner to serve multiple purposes. The upper section, fitted with narrow
shelves that pivot open, is adjustable in height and angle. The lower section has two
hinged compartments, each concealing eight small drawers.

Walderdorff, a prince of the Holy Roman Empire, was the major patron of the
German cabinetmaker Abraham Roentgen, commissioning more than twenty pieces
from his workshop in the 1750s and 1760s.

75 Writing and Toilet Table
 French (Paris), circa 1754
 Stamped J. F. OEBEN for
 Jean-François Oeben
 (1721–1763; master 1761)

Oak veneered with kingwood,
tulipwood, amaranth, boxwood, holly,
burr maple, pear, satinwood, lemon,
padouk, and stained hornbeam and
maple; leather; silk linings; gilt-bronze
mounts
Height: 71.1 cm (28 in.)
Width: 80 cm (31½ in.)
Depth: 42.8 cm (16⅞ in.)
71.DA.103

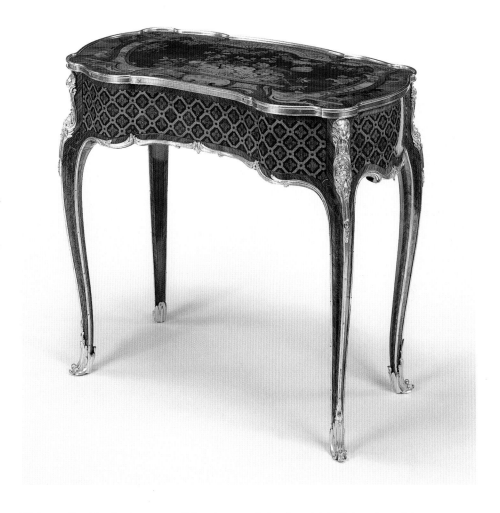

This small table displays two of the characteristics for which Oeben is well known: fine marquetry and movable fittings. The top of the table slides back. A drawer that occupies the whole of the body of the piece can be pulled out and has a sliding top, released by depressing a button. The interior is divided into compartments and lined with pale blue silk. The sliding top of the drawer is covered with trellis marquetry surrounding a shaped panel of leather, tooled and gilded with lilies around its edge; the leather is stained to resemble burr wood. The sides of the drawer are also veneered with marquetry: a rare refinement.

A very similar table appears in a painting of Madame de Pompadour by François Guérin. As she is shown with her daughter Alexandrine, who died in 1754, the portrait must have been painted before that date. Madame de Pompadour was a patron of Oeben's, and the table in the painting could be the Museum's or a closely similar one in the Musée du Louvre, Paris.

76 One of a Pair of Vases
(*Pots-Pourris Fontaines* or
à Dauphin)
French (Sèvres manufactory),
circa 1760
After a design attributed to
Jean-Claude Duplessis *père*
(died 1774; artistic director at
Sèvres 1745/48–1774), with
painting attributed to Charles-
Nicolas Dodin (1734–1803)

Soft-paste porcelain, pink (*rose*),
green (*vert*), and *bleu lapis* ground
colors, polychrome enamel decoration,
gilding. Painted underneath the
central section with the blue crossed
L's of the Sèvres manufactory.
Height: 29.8 cm (11¾ in.)
Width: 16.5 cm (6½ in.)
Depth: 14.6 cm (5¾ in.)
78.DE.358.1–.2

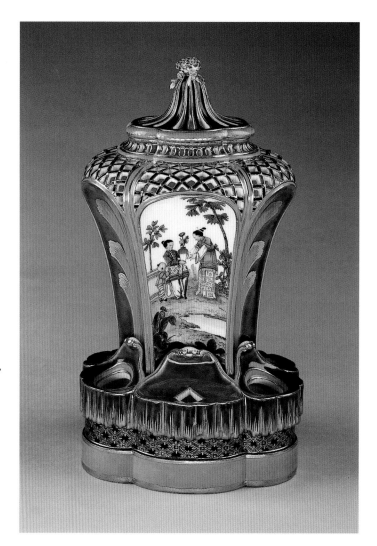

The complexity of this vase's shape and its decoration reveal the level of skill and
virtuosity achieved by the craftsmen employed at the royal Sèvres manufactory. The
base is modeled with ripples and waves simulating cascading water, hence its name,
pot-pourri fontaine. The tall central section is intended to hold pot-pourri, while
flowering bulbs, or porcelain flowers on gilt-bronze stems, could be placed in the base.

The Museum's pair of vases formed part of a garniture owned by Madame de
Pompadour, mistress of Louis XV. It is known from an inventory taken after her death
in 1764 that the garniture was displayed on the mantelpiece in the bedroom of her
Parisian hôtel (now the Palais de l'Elysée). The set was accompanied by a matching pair
of porcelain wall lights and a vase *vaisseau à mât*, also described in the same inventory.
These pieces *en suite* survive in the Musée du Louvre, Paris.

77 Lidded Pot-Pourri Vase
 (*Vase* or *Pot-Pourri Vaisseau
 à Mât*)
 French (Sèvres manufactory),
 circa 1760
 After a design attributed to
 Jean-Claude Duplessis *père*
 (died 1774; artistic director at
 Sèvres 1745/48–1774), with
 figural scene on the front
 attributed to Charles-Nicolas
 Dodin (1734–1803)

Soft-paste porcelain, pink (*rose*) and
green (*vert*) ground colors, polychrome
enamel decoration, gilding. Painted
in blue underneath with the crossed
L's (partly abraded) of the Sèvres
manufactory.
Height: 37.5 cm (14¾ in.)
Width: 34.8 cm (13¹¹⁄₁₆ in.)
Depth: 17.4 cm (6¹³⁄₁₆ in.)
75.DE.11

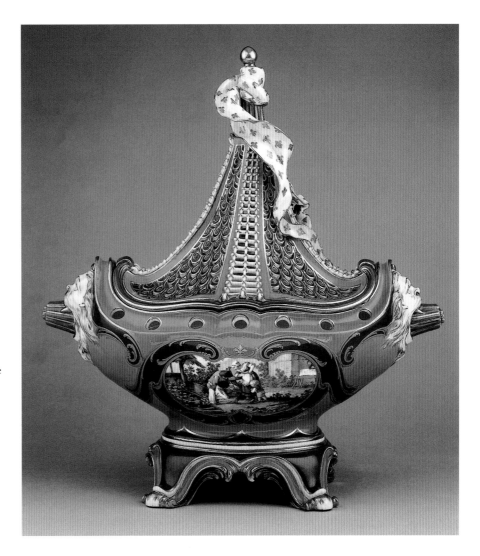

This boat-shaped vase is one of the most celebrated models introduced at Sèvres. These
vases are among the largest Sèvres vessels made at the time and show consummate skill
in the firing of the clay. The shape was produced from 1757 to 1764. The colored
scene painted on the front reserve is based on engravings of *fêtes flamandes* by Le Bas
after paintings by David Teniers the Younger (1610–1690). *Vaisseau à mât* (masted
ship) vases have varying decoration and were made to be sold with other vases of
different shapes forming garnitures. Only twelve of these vases were produced at
Sèvres, ten of which have survived into the twentieth century.

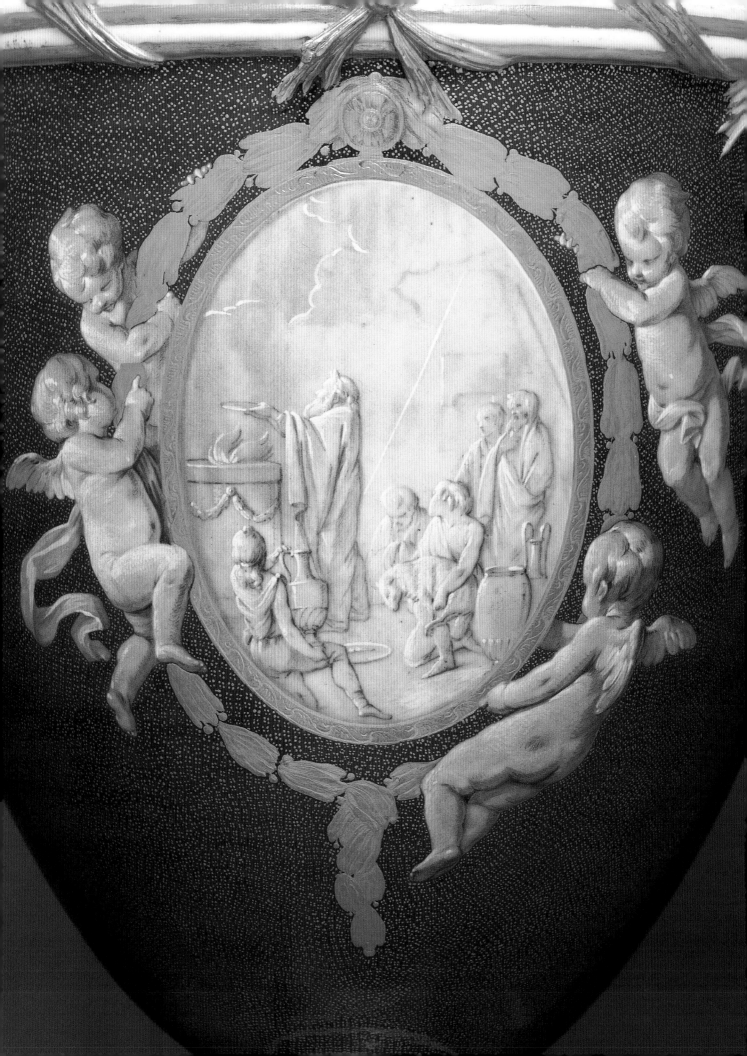

78 One of a Pair of Lidded Vases
(*Vases Oeufs*)
French (Sèvres manufactory),
circa 1769
Figural scene on the front
attributed to Jean-Baptiste-
Etienne Genest (1722/23 or
1730–1789)

Soft-paste porcelain, blue (*bleu Fallot*)
ground color, grisaille enamel
decoration, gilding; gilt-bronze mount
Height: 45.1 cm (17¾ in.)
Width: 24.1 cm (9½ in.)
Depth: 19.1 cm (7½ in.)
86.DE.520.1–.2

Detail at left

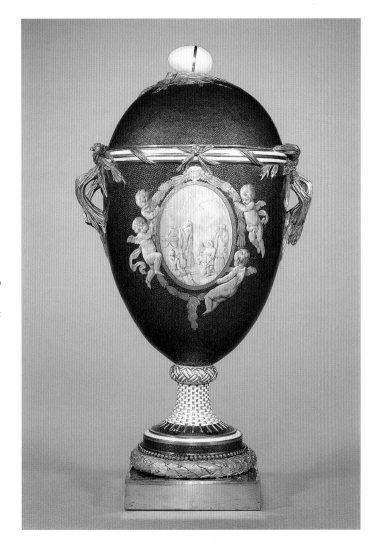

The Museum's pair of *vases oeufs* are of almost unique form: one other vase of the same model was at the Gatchina Palace, St. Petersburg, in 1914, but its present whereabouts are unknown. The ground color, *bleu Fallot*, was introduced in 1764 and is found on pieces dating to 1771. The decorative technique employed here is known as *incrusté*, that is, the *bleu Fallot* ground color has been scraped away before firing to allow for the grisaille reserves and for the areas in which the supporting putti were to be painted. The technique was frequently employed by the painter Genest; for this reason, the decoration is attributed to him.

The detail of the painted reserve at left shows a sacrificial scene. Its exact significance and source have yet to be determined.

79 Cabinet
French (Paris), circa 1765
Stamped JOSEPH for Joseph
Baumhauer (died 1772; *ébéniste
privilégié du Roi* circa 1749)

Oak veneered with ebony, tulipwood,
and amaranth; set with panels of
Japanese lacquer with extensions of
French *vernis Martin;* gilt-bronze
mounts; copper; jasper top
Height: 89.6 cm (35¼ in.)
Width: 120.2 cm (47⅜ in.)
Depth: 58.6 cm (23⅛ in.)
79.DA.58

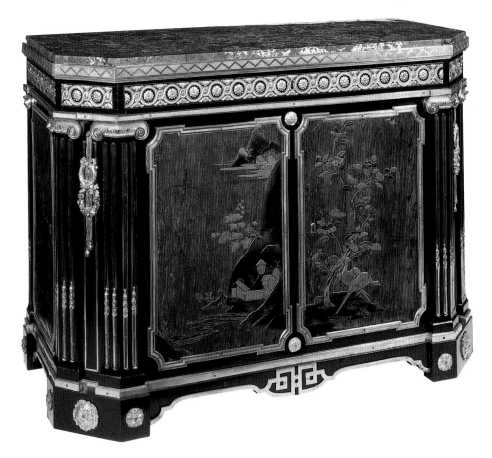

The form of this cabinet is severely architectonic and includes such classical elements
as fluted, canted pilasters and Ionic capitals. It is made of rare and expensive materials.
The large panels of Japanese lacquer date from the seventeenth century and are made
in a technique known as *kijimakie:* with this type of lacquer, the wood itself is the
exposed ground, which has been sanded to heighten its strong grain; only the elements
of the design are of raised lacquer. Large panels made with this technique are rarely
found on French furniture of this period. The flutes of the Ionic pilasters are filled with
sheets of copper to give added richness to the color and contrast with the gilt-bronze
mounts. The top is not of the usual marble but of yellow jasper, a semiprecious stone.

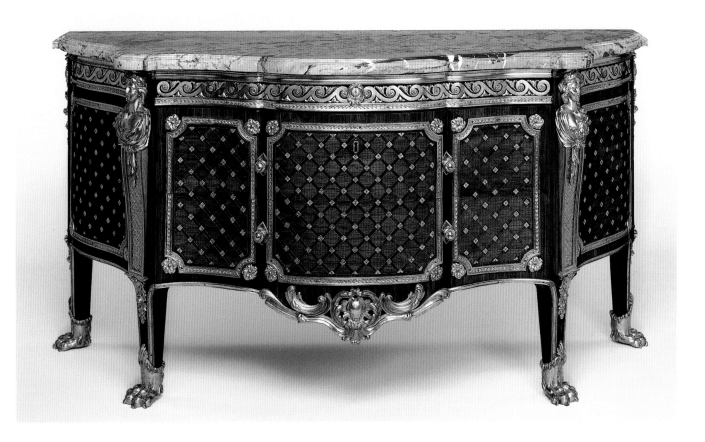

80 Commode

French (Paris), 1769

By Gilles Joubert (1689–1775;
*ébéniste ordinaire du Garde-
Meuble de la Couronne* 1758;
ébéniste du Roi 1763–1774)

Oak veneered with kingwood,
tulipwood, holly, bloodwood, or *bois
satiné* and ebony; gilt-bronze mounts;
sarrancolin marble top
Height: 93.5 cm (36¾ in.)
Width: 181 cm (71¼ in.)
Depth: 68.5 cm (27 in.)
55.DA.5

On August 28, 1769, this chest of drawers was delivered with its pair by the royal
cabinetmaker Joubert to the château of Versailles for use in the bedchamber of
Madame Louise (1737–1787), a daughter of Louis XV. The *Journal* of the royal
household's furnishings recorded its maker and dimensions, provided a detailed
description, and assigned an inventory number, 2556.2, which is inscribed boldly
on its reverse. The companion piece is now lost.

Joubert enjoyed a long career supplying furniture to the royal household from
1748 until his retirement in 1774. His early work in the Rococo taste evolved during
the 1760s toward the Neoclassical style exemplified by this commode.

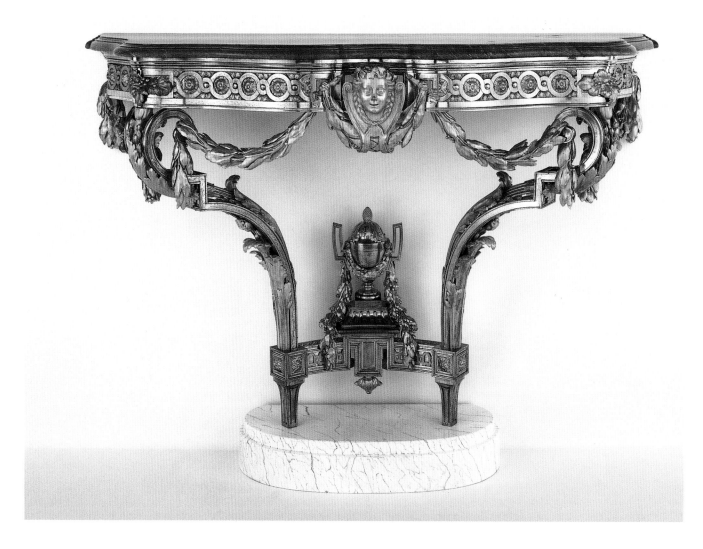

81 Console Table
French (Paris), circa 1765–1770
Designed by Victor Louis
(1737–1807), attributed to
Pierre Deumier (active from the
1760s)

Silvered and gilt bronze; *bleu turquin*
marble top; modern marbleized base
Height: 83.5 cm (31⅞ in.)
Width: 129.5 cm (51 in.)
Depth: 52 cm (20½ in.)
88.DF.118

The design of this console follows a drawing, dated 1766, signed by the architect
Victor Louis, made for Stanislaus-August Poniatowski, King of Poland. That table was
delivered to the Royal Palace in Warsaw in 1769. Its present whereabouts are unknown.

Furniture made entirely of metal is rare, and very few pieces exist today. This
console, executed in the massive early Neoclassical style, was almost certainly made
by Pierre Deumier, a worker in fine metals who was registered as a locksmith. He
advertised, in a French newspaper of 1763, a table whose description closely matches
this console. Between 1766 and 1768, he provided works to the value of 25,714 *livres*
for the Polish court at Warsaw.

82 Mantel Clock
 French (Paris); circa 1772
 Case attributed to Etienne
 Martincourt (died after 1791;
 master 1762). Clock dial signed
 CHARLES LE ROY/A PARIS
 and movement engraved *Chles
 LeRoy AParis* for the workshop
 of Charles Le Roy (1709–1771;
 master 1733), which was taken
 over after his death by his son
 Etienne-Augustin Le Roy
 (1737–1792; master 1758).
 Two movement springs signed
 and dated *Richard fevrier 1772*.

 Gilt bronze; enameled metal clock dial;
 glass clock door
 Height: 71.1 cm (28 in.)
 Width: 59.7 cm (23½ in.)
 Depth: 32.4 cm (12¾ in.)
 73.DB.78

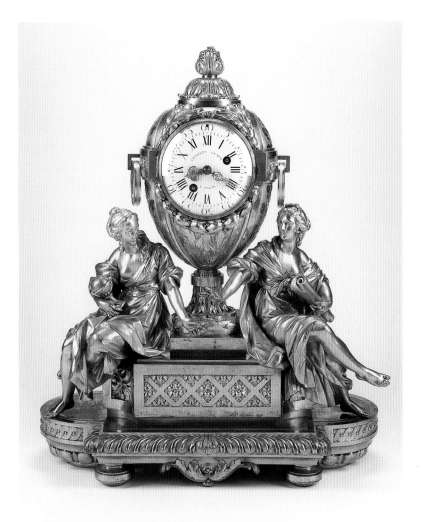

This clock is a remarkable work of casting, since details like the rosettes in the trellis
were cast together with the elements they decorate. (The usual practice was to cast all
these pieces separately.) The female figures representing Astronomy and Geography
are well modeled and must have been made by an accomplished sculptor. As is often
the case with objects made entirely of bronze, the clock does not bear the name of the
bronzier. However, a drawing of this clock signed by the *bronzier* Etienne Martincourt
survives, and in an inventory of the clockmaker Jean-André Lepaute, a similar clock is
described as being modeled by Martincourt. This clock belonged to Louis XVI, since
a 1790 inventory of royal possessions lists a clock of this model with a dial signed
Charles Le Roy as being in the king's Salle du Conseil at the Palais des Tuileries, Paris.

83 Music Stand
French (Paris), circa 1770–1775
Attributed to Martin Carlin
(circa 1730–1785; master 1766)

Oak veneered with tulipwood,
amaranth, holly, and fruitwood;
incised with colored mastics;
gilt-bronze mounts
Max. height: 148.6 cm (58½ in.)
Min. height: 94.2 cm (37 in.)
Width: 50.2 cm (19¾ in.)
Depth: 36.8 cm (14½ in.)
55.DA.4

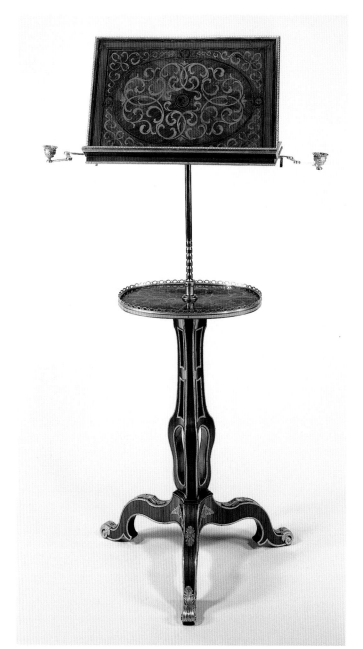

Around the third decade of the eighteenth century, French designers and cabinetmakers developed highly specific forms of furniture to meet the needs of their patrons. Stands such as this furnished *salons,* music rooms, or smaller *cabinets* where guests gathered for conversation or entertainment. Designed to hold sheets of music at an angle and fitted with extending arms for candles, the shelf can still be adjusted for a seated or standing musician.

Martin Carlin worked in a refined Neoclassical style known as the *style étrusque* or *arabesque,* almost exclusively for dealers known as *marchands-merciers.*

84 *Secrétaire*

French (Paris), circa 1770–1775
Stamped MONTIGNY for
Philippe-Claude Montigny
(1734–1800; master 1766)

Oak veneered with tortoiseshell, brass,
pewter, and ebony; gilt-bronze mounts
Height: 141.5 cm (55½ in.)
Width: 84.5 cm (33 in.)
Depth: 40.3 cm (15¾ in.)
85.DA.378

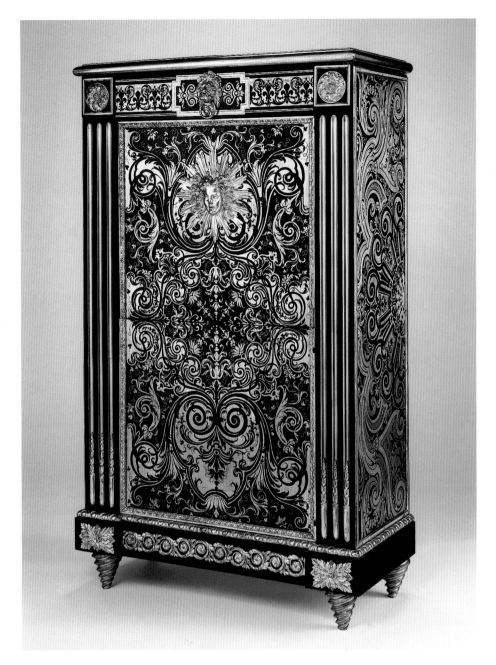

Montigny is mentioned in a Paris newspaper of 1777 as being well known for making
furniture in tortoiseshell, ebony, and brass, "in the style of the celebrated Boulle." For
this *secrétaire* he used the tops of two late-seventeenth-century tables, probably made
by Boulle. One forms the front of the *secrétaire,* cut in half in order to provide both a
fall front and a cupboard door below. The second top has been cut along its length and
used to decorate the sides of the *secrétaire.* The central motif of this latter tabletop is
an enlargement of a motif of similar design found in the center of a table attributed to
Boulle (no. 43).

The gilt-bronze mounts and the form of the *secrétaire* are typical of the early
Neoclassical style known as the *goût grec* that was popular among the most fashionable
aristocrats of the time. Indeed, the *secrétaire* is well described in the catalogue of the
sale of the courtier Monsieur de Billy in 1784. It appears again in the sale of the comte
de Vaudreuil in 1787.

85 One of a Pair of Vases
 (?) French (Paris),
 circa 1765–1770
 After an engraving by Benigno
 Bossi (1727–1792) of a design
 by Ennemond-Alexandre Petitot
 (1727–1801)

 Porphyry; red marble; gilt-bronze
 mounts
 Height: 38.7 cm (15¼ in.)
 Width: 41 cm (16⅛ in.)
 Depth: 27.7 cm (10⅞ in.)
 83.DJ.16.1.–.2

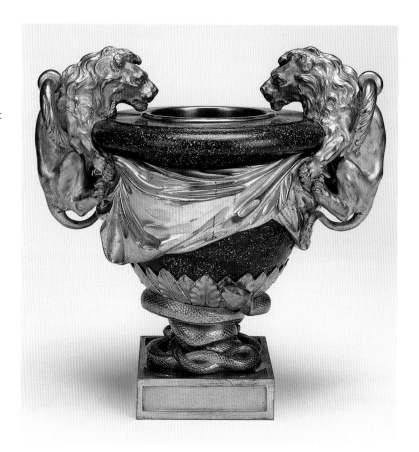

The design of the Museum's pair of vases closely follows an engraving of a design by
Petitot that was published in 1764 as one of a set of thirty-one prints of vases. Petitot,
though born in France, moved to Parma in 1753, where he became court architect
to Ferdinand, Duke of Parma (1751–1802). The set of engravings is dedicated to
Guillaume-Léon du Tillot, Marquis of Felino (1711–1774), first minister of Parma.
Three other designs were used as the basis for three large garden vases for the ducal
gardens, but most of the engravings were purely fantastical.

 While the porphyry bodies of the vases were probably made in Italy, it is likely
that the vases were placed on their mounts by an as-yet-unknown Parisian *bronzier*.

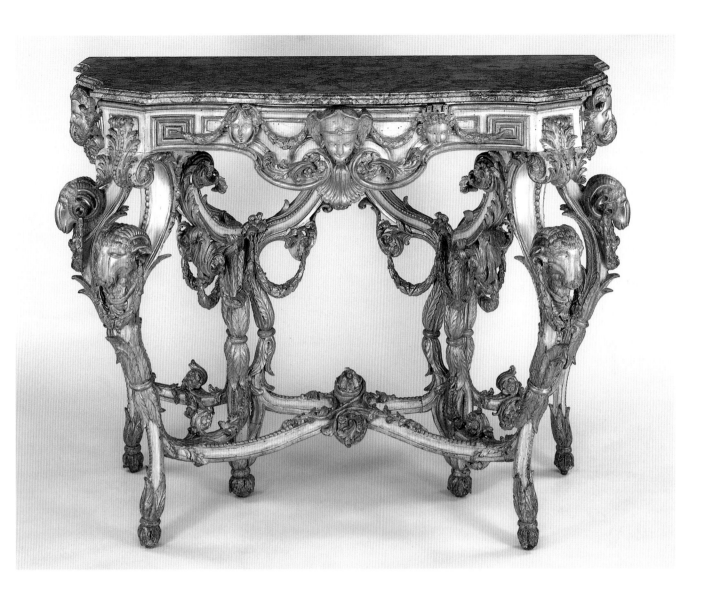

86 Side Table
Italian, circa 1760–1770

Carved and gilt spruce and limewood
surmounted by a rare stone top
Height: 105 cm (41⁵/₁₆ in.)
Width: 153 cm (60¼ in.)
Depth: 74 cm (29⅛ in.)
87.DA.135

The openwork form of this table is a remarkably inventive example of the Rococo taste for delicately complex, curvilinear elements. Standing on six feet, this table is composed of four outer legs and two sets of intertwined inner legs, connected by curving stretchers and embellished with deeply draping garlands. Combined with this unusual and capricious form, the table displays the more sober Neoclassical style of the second half of the eighteenth century. Such antique-inspired ornament as rams' heads, acanthus leaves, and the geometric key around the rail indicate that the unknown maker was influenced by the furniture designs of Giovanni Battista Piranesi (1720–1778), one of the principal forces behind the birth and development of the Neoclassical style in Europe.

This table's unusual interpretation of the prevailing trends in Italian furniture design of the second half of the eighteenth century suggests that it was made in a center outside the mainstream, such as in the Emilian city of Parma, where a type of fanciful and elegant Neoclassical furniture was being produced at the time.

87 One of a Pair of Mounted Vases
 Porcelain: Chinese (Kangxi),
 1662–1722
 Mounts: French (Paris),
 circa 1770–1775

Porcelain, black ground color, gilding
(mostly abraded); gilt-bronze mounts
Height: 49 cm (19¼ in.)
Width: 24.7 cm (9¾ in.)
Depth: 20 cm (7⅞ in.)
92.DI.19.1–.2

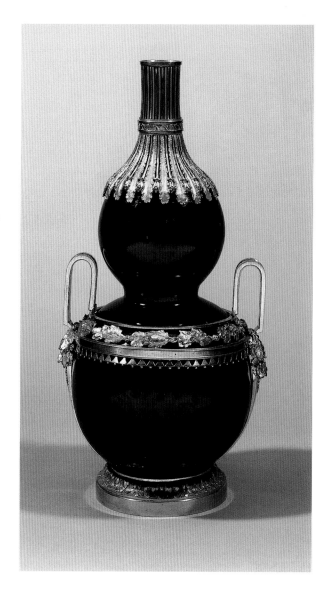

This vase is of a rare type of Chinese porcelain known as "mirror black" ware because
of its intensely hard glaze and lustrous finish. This type of monochrome Chinese
porcelain was apparently an innovation of the Kangxi period and should not be
confused with the so-called *famille noire* enameled wares that were so popular with
collectors during the nineteenth century.

 The gilt-bronze mounts that decorate this vase and its pair appear to be of unique
design. The identity of the *bronzier* who made the mounts is not known; nevertheless,
the fine design and high quality of the mounts indicate the hand of a craftsman of
significant accomplishment. They are in the Neoclassical style fashionable in Paris
during the 1770s and may have been influenced by the decorative engravings of Jean-
Charles Delafosse (1734–1789), which began to appear in 1768. The vases were once
fitted with small gilt-bronze lids, now lost.

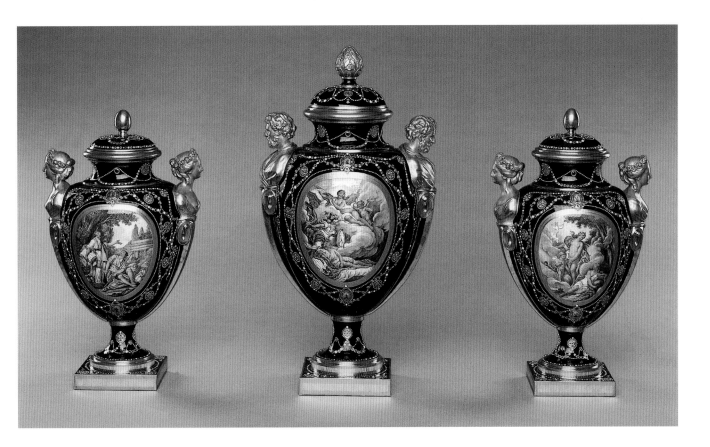

88 Garniture of Three Vases
(*Vases des âges*)
French (Sèvres manufactory), 1781
After designs by Jacques-François
Deparis (active 1735–1797),
modeled by Etienne-Henry Bono
(born 1742; active 1754–1781),
painted by Antoine Caton (active
1749–1798), after engravings
by Jean-Baptiste Tilliard (circa
1740–1813); enamel jeweling
by Philippe Parpette (1736–
circa 1808) and flat gilding
by Etienne-Henri Le Guay
père (1719/20–1799)

Soft-paste porcelain, *bleu nouveau*
ground color, polychrome enamel
decoration, opaque and translucent
"jewels," gilding, and gold foils. Two
of the vases are painted with the crossed
L's of the Sèvres manufactory and the
initials *LG*, all in gold.
(Center vase): Height: 47 cm (18½ in.)
Width: 27.7 cm (10⅞ in.)
Depth: 19.3 cm (7⅝ in.)
(Side vases): Height: 40.8 cm (16 in.)
Width: 24.8 cm (9¾ in.)
Depth: 18.4 cm (7¼ in.)
84.DE.718.1–.3

This model, produced at the Sèvres manufactory from 1778, was called the *Vases des âges*. It was made in three sizes: the largest was set with the heads of old men, the second with the heads of young women, and the smallest with the heads of boys. The Museum's three vases once formed part of a garniture of five that were sold by the manufactory to Louis XVI in 1781. They were displayed in his library at Versailles. The two smaller vases that completed the garniture can now be found in the Walters Art Gallery, Baltimore.

The painted scenes on the fronts of the vases are based on engravings used to illustrate Fénelon's *Les Aventures de Télémaque*. The expensive technique of using stamped gold foils set with colored enamels, imitating jewels, pearls, and moss agates, was used at Sèvres between 1780 and 1785. It was primarily employed for the decoration of cups and saucers that were collected for display rather than use. It is rarely found on larger wares, such as these vases.

89 *Secrétaire*
French (Paris), circa 1775
By René Dubois (1737–1799;
master 1755; *ébéniste de la Reine*
1779)

Oak veneered with kingwood,
tulipwood, holly, dyed hornbeam, and
ebony; incised with colored mastics;
set with mother-of-pearl; gilt-bronze
mounts; gray marble top
Height: 160 cm (63 in.)
Width: 70.2 cm (27⅝ in.)
Depth: 33.7 cm (13¼ in.)
72.DA.60

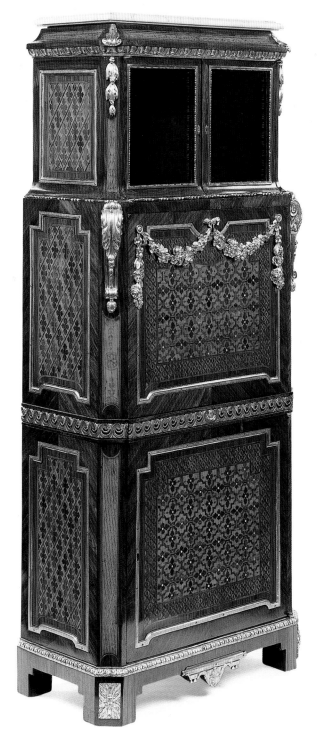

This *secrétaire* is of utilitarian form and provided its owner with a storage cupboard
below, a writing surface complete with pigeonholes concealed behind the fall front,
and a display shelf fitted with glass doors. The rectilinear form is softened by the veneer
pattern of marquetry quatrefoils incorporating mother-of-pearl and by the gilt-bronze
floral swags mounted at the top of the fall front.

René Dubois was the son of the cabinetmaker Jacques Dubois (see no. 71), and
the activity of the family workshop spanned fifty years, ending in ruin during the
French Revolution. René Dubois worked primarily for dealers, specializing in furniture
with painted finishes.

90 *Secrétaire*

French (Paris), circa 1776–1777
Secrétaire stamped M.CARLIN
for Martin Carlin (circa 1730–
1785; master 1766); the two
large porcelain plaques painted
by Edme-François Bouillat
(1739/40–1810); the two
smallest plaques painted by Raux
fils aîné (active 1766–1779)

Oak veneered with tulipwood and
amaranth with holly and ebony
stringing; set with five Sèvres soft-
paste porcelain plaques, with borders
of turquoise-blue (*bleu céleste*) ground
color, polychrome enamel decoration,
and gilding; enameled metal; gilt-
bronze mounts; white marble top.
One porcelain plaque has the date
letter Y on the back for 1776; another
plaque has the date letter Z on the
back for 1777.
Height: 107.9 cm (42¼ in.)
Width: 103 cm (40½ in.)
Depth: 35.5 cm (14 in.)
81.DA.80

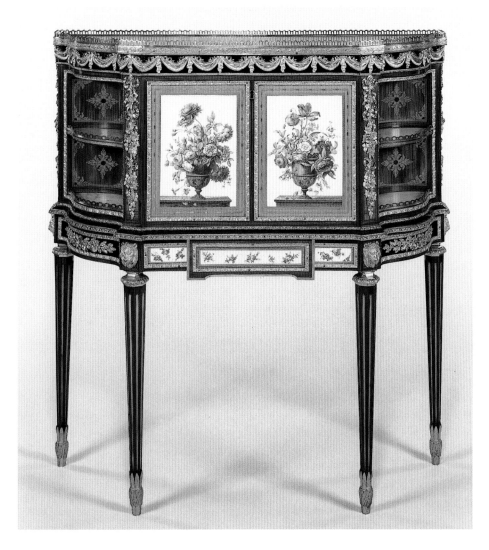

The upright *secrétaire* began to be a fashionable form of furniture at the end of the first
half of the eighteenth century. The fall front lowers to form a writing surface, revealing
drawers and pigeonholes.

Martin Carlin specialized in making furniture mounted with Sèvres porcelain
plaques. This expensive form of decoration began about 1760 and within ten years
became extremely fashionable. The decoration of the two large plaques (known as
plaques carrées) is of a type found on a variety of Sèvres wares of the mid-1770s,
although the execution is generally less meticulous than that on the Museum's examples.

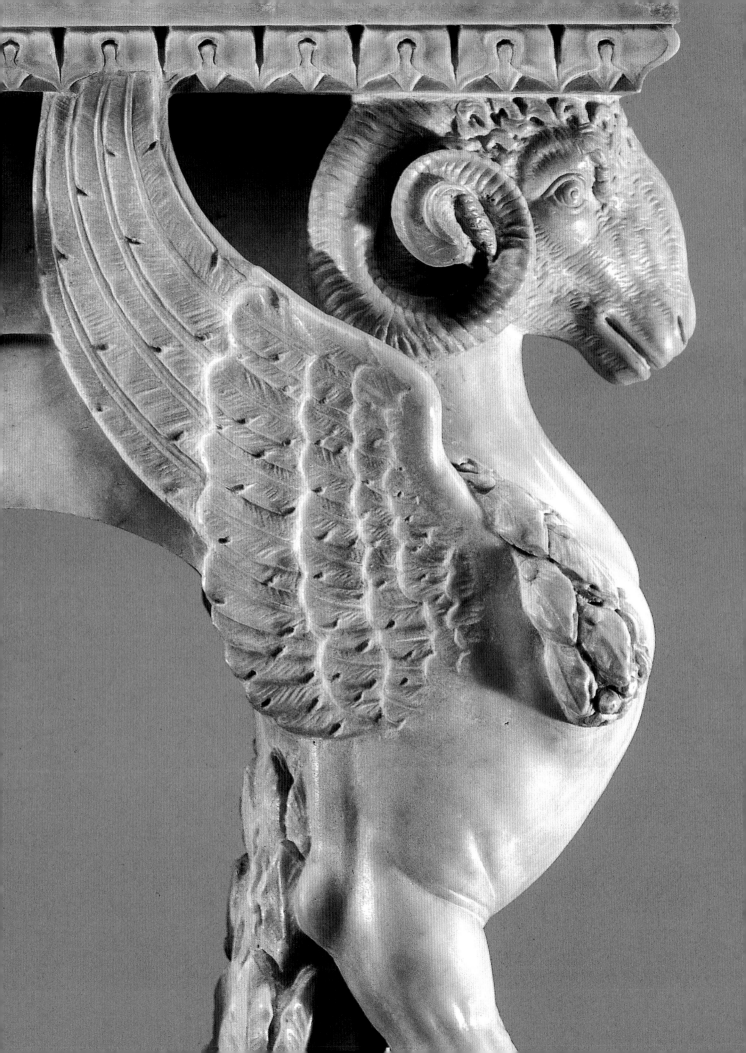

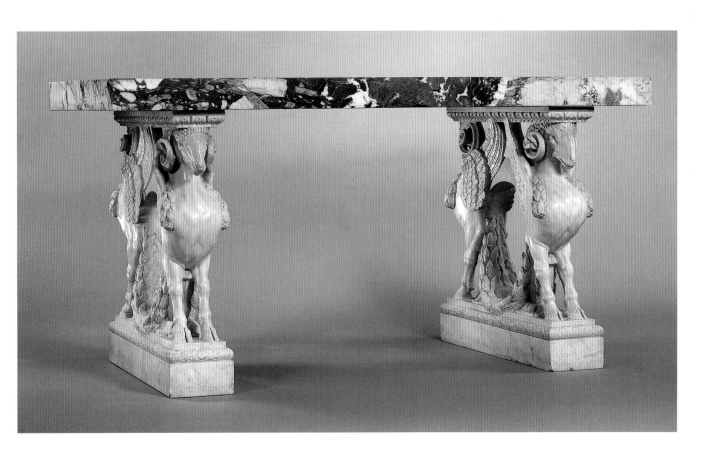

91 Table
Italian (Rome), circa 1780
By Francesco Antonio Franzoni
(Carrara, active in Rome;
1734–1818)

Marble
Height: 100 cm (39½ in.)
Width: 200 cm (79 in.)
Depth: 81 cm (32 in.)
93.DA.18

Detail at left

The designer of this table, Francesco Antonio Franzoni, was one of the most important sculptors and restorers of antique sculpture active in Rome in the last quarter of the eighteenth century. His unique designs, one of the most remarkable of which is this table, are characterized by the imaginative use of classical motifs combined with restrained Neoclassical ornament. Franzoni is best known for his work in the Museo Pio-Clementino, the Vatican museum of antiquities, for which he not only helped restore a number of important antique sculptures and decorative works but also provided decoration and furnishings. In fact, in the Sala degli Animali of this museum are a pair of tables nearly identical to the Getty piece; they were originally commissioned by Pope Pius VI for the Sala dei Busti.

The beautifully conceived and carved pier supports include winged rams (see detail at left) joined by laurel swags and standing on elegantly molded plinths. These supports bear a top made of an extraordinarily large and thick slab of *breccia Medicea,* a spectacular specimen displaying purple, red, and white chunks of stone that was obtained from the quarry operated by the Medici in the Apuan Alps.

92 Tapestry: "L'Entrée de Sancho dans l'Ile de Barataria" from the series *L'Histoire de Don Quichotte* French (Paris), 1771–1772 Woven at the Gobelins manufactory in the workshop of Michel Audran (1701–1771) and Jean Audran *fils* (*entrepreneur* at the Gobelins, 1771–1794), after a cartoon painted by Charles-Antoine Coypel (1694–1752). *Alentour* (decorative surround) designed 1721–1760 by Jean-Baptiste Belin de Fontenay *fils* (1668–1730), Claude (III) Audran (1658–1734), Alexandre-François Desportes (1661–1743), and Maurice Jacques (circa 1712–1784); cartoon painted by Antoine Boizot (circa 1702–1782).

Wool and silk; modern cotton lining
Height: 368 cm (145 in.)
Width: 414 cm (163 in.)
82.DD.68

Detail at right

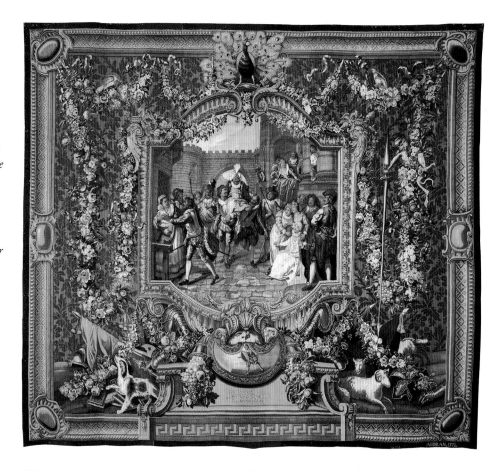

This tapestry portrays a scene from the highly popular romance by Miguel de Cervantes Saavedra (1547–1616), known in French as *Don Quichotte*. From 1717 until 1794, the Gobelins tapestry manufactory produced woven images of the Spanish knight's humorous adventures, basing them on twenty-eight painted models provided by the artist Coypel. This example, bearing the date 1772, and three others *en suite* were presented by Louis XVI in 1786 as a diplomatic gift to the Duke and Duchess of Saxe-Teschen, who were the brother-in-law and sister of Marie Antoinette.

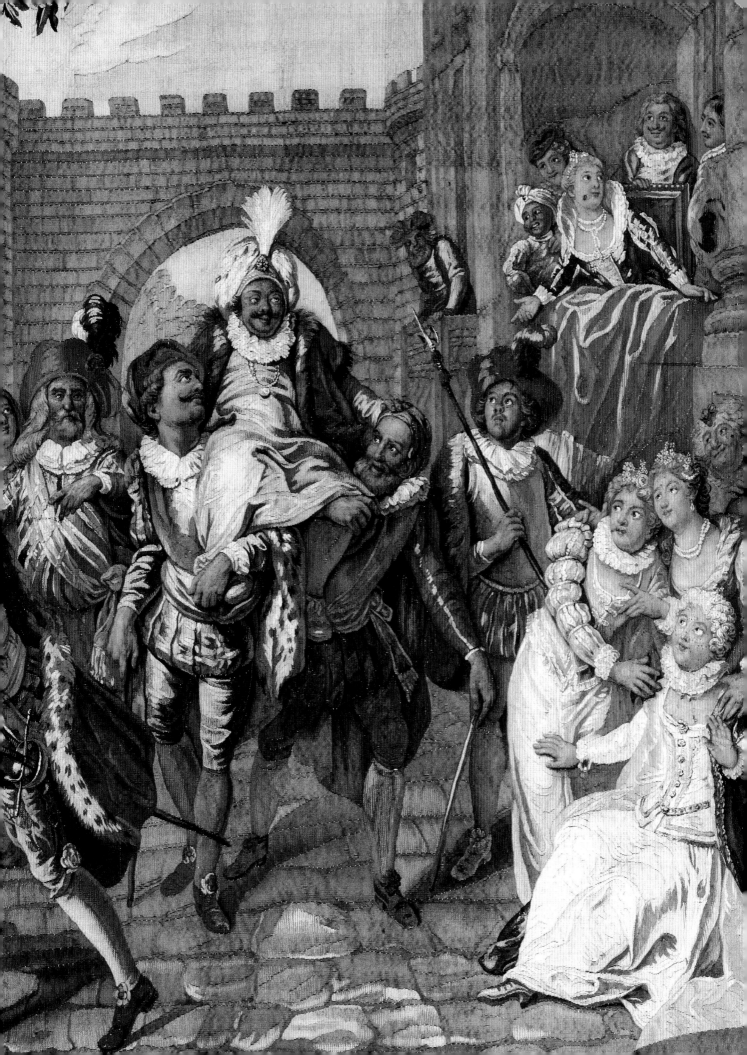

93 Cabinet

French (Paris), 1788
Stamped BENEMAN for
Guillaume Beneman (died 1811;
master 1785)

Oak veneered with ebony and
mahogany; legs of solid ebony; set with
pietre dure plaques of the seventeenth
and eighteenth centuries; gilt-bronze
mounts; *bleu turquin* marble top
Height: 92.2 cm (36¼ in.)
Width: 165.4 cm (65⅛ in.)
Depth: 64.1 cm (25¼ in.)
78.DA.361

This cabinet is one of a pair made for Louis XVI's *chambre à coucher* at the château of Saint-Cloud. It was delivered in 1788, and a memoir written in that year by Jean Hauré (*sculpteur et fournisseur de la Cour*) describes the cabinets in great detail, giving the names of the craftsmen involved in their production. Models for the gilt-bronze mounts were made by Gilles-François Martin (circa 1713–1795). They were cast by Etienne-Jean Forestier (master 1764), gilded by André Galle (1761–1844), and chased by Pierre-Philippe Thomire (1751–1843; master 1772). The marble tops were provided by Lanfant.

The cabinets were originally veneered with Japanese lacquer; a screen of four leaves was supplied by the crown repository for this purpose. At some point after the French Revolution, the lacquer was exchanged for panels of *pietre dure*.

The companion piece to the cabinet is in the Palacio Real, Madrid. It too has been changed; marquetry panels after harbor scenes by Joseph Vernet replace the original lacquer.

94 Standing Vase
 Porcelain: Chinese, Qianlong
 (1736–1795); mid-eighteenth
 century
 Mounts: French (Paris),
 circa 1785
 Attributed to Pierre-Philippe
 Thomire (1751–1843; master
 1772)

 Porcelain, blue ground color;
 gilt-bronze mounts; *rouge griotte* marble
 Height: 81 cm (31¾ in.)
 Diameter: 56.5 cm (22¼ in.)
 70.DI.115

This vase, largely of gilt bronze enclosing a large Chinese porcelain bowl, is one of a pair. One vase, the Museum's, was formerly in the collection of the Polish princess Isabella Lubormirska, who had been a friend of Marie Antoinette's; she is reputed to have acquired it at the sale of the contents of Versailles in 1794. (It passed to her great-great grandson, Count Alfred Potocki, from whom J. Paul Getty acquired it.) The other vase may have been bought at the same sale by Thomire et Cie., because it was delivered by that firm to Carlton House, the London residence of the Prince Regent (later George IV), in 1812. It is still in the British Royal Collection.

 The style of the mounts conforms closely to Thomire's early work, and elements such as the vine leaves, grapes, and curling ribbed horns are found on other works documented to him.

95 Rolltop Desk
 (*Secrétaire à Cylindre*)
 German (Neuwied-am-Rhein),
 circa 1785
 Desk attributed to David
 Roentgen (1743–1807; master
 1780); gilt-bronze plaque
 attributed to Pierre Gouthière
 (1732–1812/14; master 1758);
 some mounts by François
 Rémond (1747–1812;
 master 1774)

 Oak and pine veneered with mahogany
 and maple burl; gilt-bronze mounts;
 steel fittings
 Height: 168.3 cm (66¼ in.)
 Width: 155.9 cm (61⅜ in.)
 Depth: 89.3 cm (35⅛ in.)
 72.DA.47

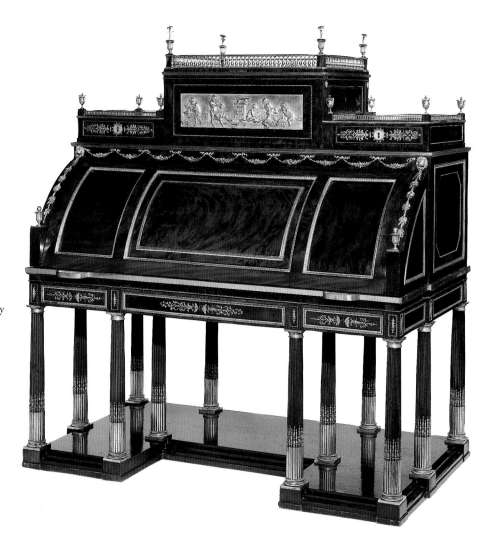

This monumental desk was made in Germany by David Roentgen, who maintained the large workshop at Neuwied that had been set up earlier in the eighteenth century by his equally famous father, Abraham (see no. 74). He sold his furniture to courts throughout Europe and was patronized by the French royal family and in 1779 was named *ébéniste-mécanicien du Roi et de la Reine*.

Roentgen's pieces were very often equipped with elaborate mechanical devices that were made by his colleague, the clockmaker and *mécanicien* Peter Kinzing (1745–1816). This rolltop desk has a typically complicated mechanical fitting. The interior, behind the rolltop, has numerous drawers that spring open when released by concealed buttons and levers. In the superstructure, behind the large gilt-bronze plaque, is a contraption of many parts that moves out and opens at the turn of a key. It contains a folding reading stand with compartments that hold an inkwell and sand pot, with a small drawer below.

96 Long-Case Musical Clock
German (Neuwied-am-Rhein),
1784–1786
The clock movement is inscribed
Roentgen & Kinzing à Neuwied
for David Roentgen (1743–
1807; master 1780), the maker
of the case, and Peter Kinzing
(1745–1816), the maker of the
clock movement. The gilt-bronze
mounts were supplied by
François Rémond (1747–1812;
master 1774). The musical
movement is inscribed *Jean
Guillaume Weyl Fait a Neuwied
le 16 May 178*[?] for Johann
Wilhelm Weil (1756–1813).

Oak and maple veneered with burr
maple; gilt-bronze mounts; enameled
metal clock dial; glass clock door;
blued steel
Height: 192 cm (75½ in.)
Width: 64 cm (25½ in.)
Depth: 54.5 cm (21½ in.)
85.DA.116

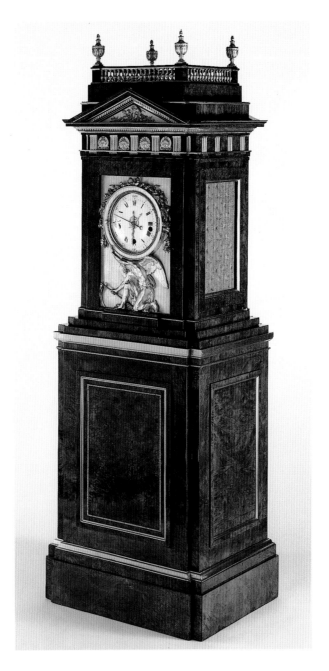

This model seems to have been the most popular clock case made by Roentgen. Many
of the other comparable examples include the figure of the sun god Apollo on top; such
a large, gilt-bronze figure of Apollo playing his lyre would almost certainly have been
placed on top of the Museum's clock as well, where the holes for an attachment exist.
This would be consistent with the other gilt-bronze decorations on this clock, all of
which are symbols of time. Chronos (Father Time) supports the clock dial. The passage
of the year is marked by the garland over the dial, with its flowers of spring, wheat of
summer, grapes of autumn, and holly leaves of winter. The faces of day and night are
shown in the roundels above, and the whole is crowned with the lyre of Apollo, who
oversees the passage of time.

97 Still Life
 French (Paris), 1789
 By Aubert-Henri-Joseph Parent
 (1753–1835)

Limewood
Inscribed under the base
AUBERT PARENT FECIT AN. 1789
Height: 69.4 cm (27⅜ in.)
Width: 47.9 cm (18⅞ in.)
Depth: 6.2 cm (2⁷⁄₁₆ in.)
84.SD.76

Detail at right

This virtuoso carving from a single plank of limewood demonstrates the accomplished skill of the maker, Aubert Parent, who came to prominence in 1777, when one of his panels was accepted as a gift by Louis XVI. Parent was known across Europe for his realistic sculptures of nature, as well as for his knowledge of classical antiquity, which he acquired during a stay in Italy from 1784 to 1788. This relief—depicting a vase of flowers on a plinth (inspired from the antique), with a pair of birds defending their nest from a grass snake—alludes to parental responsibility and, indirectly, to the duty of the French monarchy toward its subjects on the eve of the Revolution.

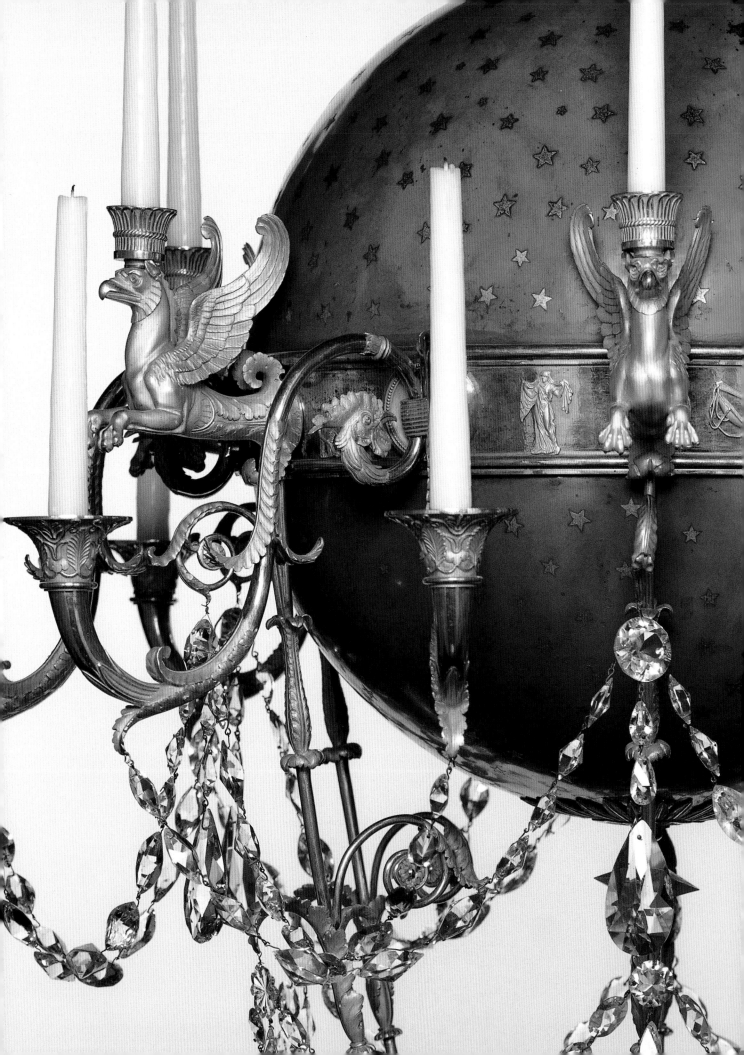

98 Chandelier
 French (Paris), circa 1818–1819
 By André Galle (1761–1844)

Glass; enameled metal; gilt bronze
Height: 129.5 cm (51 in.)
Diameter: 96.5 cm (38 in.)
73.DH.76

Detail at left

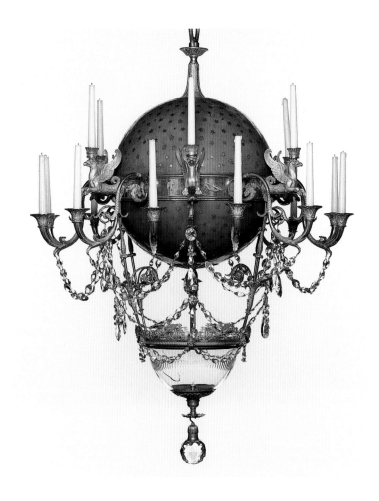

André Galle had provided work in gilt bronze both for Louis XVI and later for
Napoleon and the emperor's numerous relatives. With the Restoration under Louis
XVIII, Galle offered works to the crown that he had made for the various Paris
Expositions and ones he had made earlier, among them a chandelier of this model,
described as a *lustre à poisson* in the *Exposition des produits de l'industrie française*
of 1819. In his description, written for the king, Galle stated that the glass bowl
suspended below the globe was intended to hold goldfish, "whose continuous
movements amuse the eye most agreeably." It seems that Louis XVIII was not
amused: the chandelier does not appear in the royal inventories.

The large blue enameled globe is studded with gilt stars and encircled by the
signs of the zodiac in gilt bronze. Some of these elements—the griffins and the large
scrolls with rosettes above the glass bowl—appear in an engraving for a chandelier
in Percier and Fontaine's *Recueil de décorations intérieures* published in 1801.

99 One of a Pair of Wall Lights
 French (Paris), circa 1787
 By Pierre-François Feuchère
 (1737–1823; master 1763)

Gilt bronze
Height: 61.6 cm (24¼ in.)
Width: 32 cm (12⁹⁄₁₆ in.)
Depth: 18.5 cm (7¼ in.)
78.DF.90.1–.2

Wall lights of this model were delivered by Feuchère to the *chambre à coucher* of the Commissaire Général Thierry de Ville d'Avray at the Hôtel du Garde-Meuble in Paris in 1787. In the following year, he delivered four wall lights of the same form but with a third branch added, carrying a winged child holding a heart, for use in the *cabinet de toilette* of Marie Antoinette in the château of Saint-Cloud. They are now in the Musée du Louvre, Paris.

100 Pair of Candlesticks
 Northern Italian,
 circa 1832–1840
 By Filippo Pelagio Palagi
 (Bologna, 1775–1860)

 Gilt bronze
 Height: 90.2 cm (35½ in.)
 Width: 43.2 cm (17 in.)
 85.DF.22.1–.2

These candlesticks were designed by Filippo Pelagio Palagi, a celebrated Bolognese collector, furniture designer, painter, ornamentalist, and architect. Palagi's designs were strongly influenced by the Empire style that was being diffused in Italy by the Bonaparte courts; they also incorporated Egyptian, Greek, Etruscan, and Roman motifs, which he inventively and eclectically combined. In 1832, Palagi was selected by King Carlo Alberto of Savoy to redecorate a number of rooms in various Piedmontese royal palaces. The formal yet inventive form of these candlesticks is in keeping with the king's taste as reflected in his redecorating projects.

 Palagi's pen drawing for one of these candlesticks is in the collection of the Biblioteca dell'Archiginnasio, Bologna. This drawing, like the candlesticks themselves, exemplifies the elegant graphic quality of the artist's work.

INDEX OF ARTISTS, MAKERS, AND MANUFACTORIES

Numerals refer to page numbers